# FOR WANT OF A NAIL

### AMY FRANCESCHINI &
### MICHAEL SWAINE

FUTUREFARMERS

INTER-OFFICE MEMORANDUM

DATE October 18, 1943

TO: Mr. B. E. Brazier

FROM: Priscilla Duffield

SUBJECT:

At your convenience, will you arrange to have a table built for A-209, dimensions 26 x 30.

Mr. Oppenheimer would like a nail in his office to hang his hat on.

The middle lamp in the inside row, in A-210, has no string. One of the tubes in the lamp in A-210, which is nearest the door to A-209, does not light.

Priscilla Duffield

PLATE I:
INTER-OFFICE MEMORANDUM FOUND AT THE LOS ALAMOS
HISTORICAL SOCIETY, LOS ALAMOS, NEW MEXICO,
REQUESTING A TABLE AND A NAIL FOR MR. OPPENHEIMER'S OFFICE.

**INTER-OFFICE MEMORANDUM**

DATE Oct. 13, 1943

TO: J. G. Ryan

FROM: B. E. Brazier

SUBJECT: Table for A-209, Oppenheimer's office.

TA-1-1

Nail for hat.

Will you please build a table for Mr. Oppenheimer, A-209, 26" wide x
27" high x 30" long. Will you please build this a nice table, sand it
and varnish it. Since it is for Mr. Oppenheimer's office I would like
a nice table; he wants this for his telephone.

While you sent him a very nice coat and hat rack this morning he would
still like a nail for his hat. Please put one up in his office.

B. E. B.

r.

*Finished*

PLATE 2:
INTER-OFFICE MEMORANDUM FOUND AT THE LOS ALAMOS
HISTORICAL SOCIETY, LOS ALAMOS, NEW MEXICO,
REQUESTING A TABLE AND A NAIL FOR MR. OPPENHEIMER'S OFFICE.

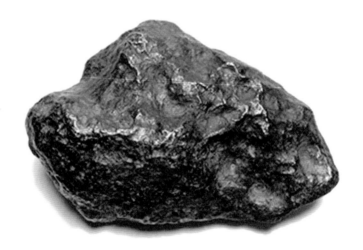

PLATE 3:
METEORITE FROM CANYON DIABLO, ARIZONA.

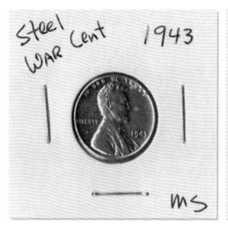 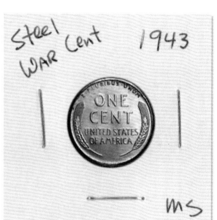

PLATE 4:
STEEL PENNIES FROM 1943 BOUGHT IN PAWNSHOP IN
OAKLAND, CALIFORNIA.

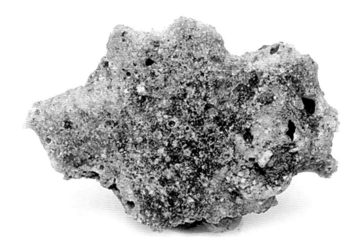

PLATE 5:
TRINITITE, CREATED JULY 16, 1945, 5:30 AM,
ALAMOGORDO, NEW MEXICO.

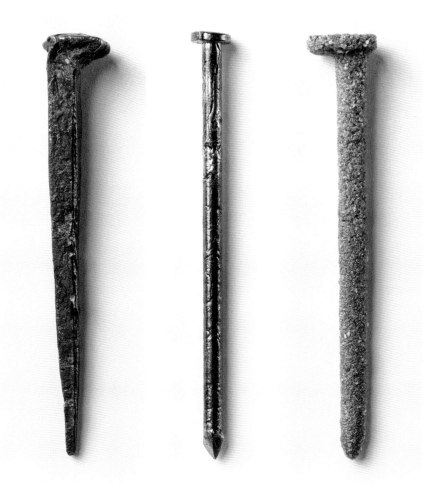

PLATE 6:
FORGED, CAST, AND RE-FUSED NAILS
FOR J. ROBERT OPPENHEIMER.

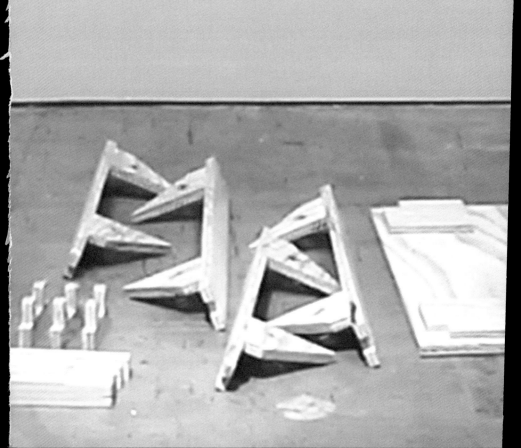

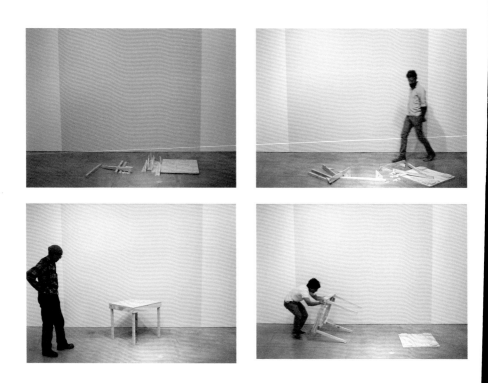

PLATE 7:
FUTUREFARMERS, VIDEO STILLS FROM *Casting Call*, 2014.

16

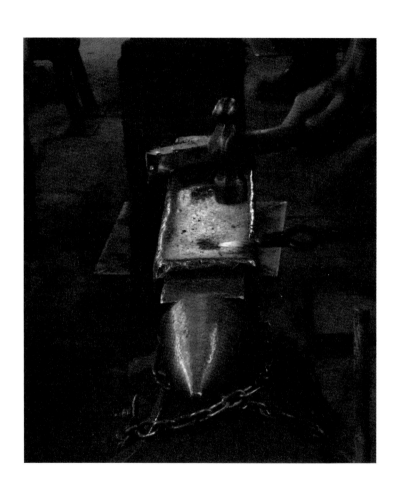

PLATE 8:
FORGING METEORITE NAIL.

PLATE 9:
ROCK SHOP, TRINITY, NEW MEXICO.

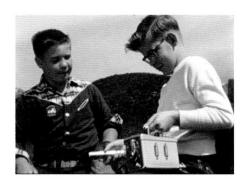

PLATE II:
FILM STILLS FROM *Prospecting for Uranium*, CA. 1956.

24

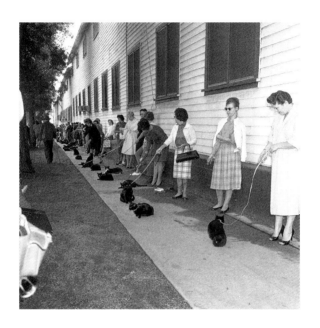

PLATE 12:
CASTING CALL FOR BLACK CATS

HOLLYWOOD HUNTS A BLACK CAT — OUT OF THIS SIDEWALK FULL OF
BLACK CATS ONE MAY BE CHOSEN FOR THE TITLE ROLE IN (NATCH) "THE BLACK CAT,"
ONE OF THREE SEGMENTS IN *Tales of Terror*, WHICH AMERICAN INTERNATIONAL
PICTURES IS CASTING AT PRODUCERS STUDIO. DIRECTOR ROGER CORMAN HOPES TO
FIND SIX LOOK-ALIKES — ONE TO STAR, THE OTHERS TO STAND IN — FOR THE MOVIE
THRILLER STARRING VINCENT PRICE, PETER LORRE, JOYCE JAMESON.

# SETTING THE TABLE: AN INTRODUCTION

FUTUREFARMERS

THIS BOOK MARKS THE CULMINATION of Futurefarmers's project *Forging a Nail*. Begun as a site-specific contribution to an exhibition in Santa Fe, New Mexico, *Forging a Nail* engages the region's complex nuclear history though an amalgamation of primary research, speculation, and artistic imagining. Throughout this multidisciplinary project, Futurefarmers has constructed a narrative that runs parallel, and in some cases counter to, the conventional accounts of the Manhattan Project and its chief architect, Dr. J. Robert Oppenheimer. This project not only opens new ways to think about the region's particular history (and the so-called father of the A-bomb) but also prompts more general reflections on how knowledge and narrative are embedded and communicated in material objects, both ephemeral and ancient.

A series of curious memoranda sent from Oppenheimer's office in October 1943 and archived in the Los Alamos Historical Society provided the starting point for this project. In a memo to the Buildings and Maintenance Department, the scientist's secretary asked that the department build a modest table for his telephone and drive a nail into the wall, so that Oppenheimer would have a place to hang his hat. After a coat and hat rack was promptly delivered, Oppenheimer reiterated the request for a nail, and his secretary sent a second memo with the subject "Nail for hat." The persistence and specificity of the request for this nail, along with the suggestion that one of the twentieth century's most prominent theoretical physicists might be incapable of using simple

tools, inspired Futurefarmers to create, by hand (and after a half-century delay), a nail for Oppenheimer.

In the end, not one but three nails were produced. The first was forged using a "Canyon Diablo meteorite," metal that fell from the sky fifty thousand years ago, creating Arizona's Barringer Crater, a hole one kilometer wide made with a force equivalent to 150 atomic bombs. The second nail was made through a process of melting pennies from 1943, the year of Oppenheimer's request. These one-cent pieces, also known as "war pennies," are distinctive, since that year the U.S. Treasury cast them in zinc-coated steel, rather than the customary copper, which was being requisitioned for the war effort. Finally, Futurefarmers formed a third nail through a process of re-fusing Trinitite, the glassy residue left on the floor of the New Mexico desert after the first atomic test. This radioactive material points to the moment when humans indelibly marked the earth; everything that has grown on the earth's surface from this point forward has been inscribed with what scientists call the isotopic fingerprint—a permanent record of this event. In different ways these three objects serve to open up the complexity of the production connected to the Manhattan Project, as well as to acknowledge the long history of resource extraction in the American Southwest.

*Casting Call* is another work inspired by Oppenheimer's memo. For this event and resulting video documentation, Futurefarmers built a plywood kit version of the table he requested, and, by open call, invited ten "actors" to assemble the table over the course of a day. Provided with an exploded view—all the parts Futurefarmers imagined necessary to build the table described in the memorandum—but no diagrams or instructions, the actors were asked to assemble a table and then to take it apart. The event, and its five-minute video documentation, resulted in ten distinct variations of a table constructed by ten individual participants.

This publication offers another opportunity to consider the continuum of tools developed by humans—from a simple

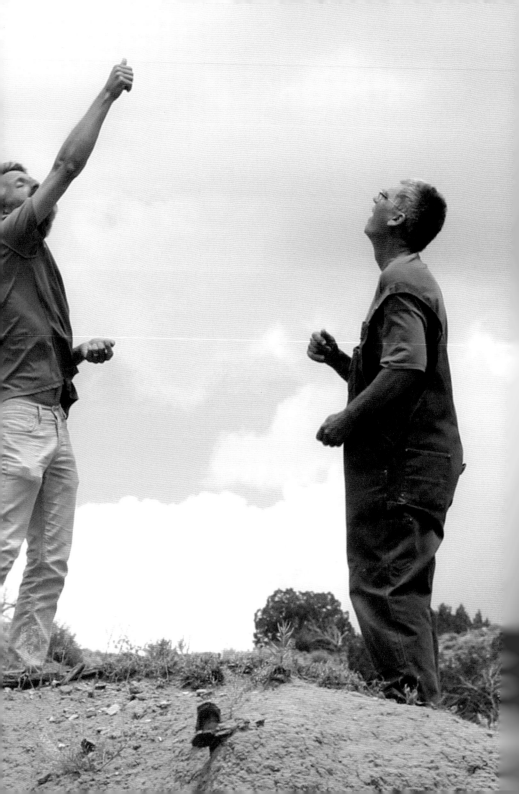

forged nail to a rudimentary desk table to a complex atomic bomb. Futurefarmers asked art critic Lucy Lippard, historian of science Peter Galison, publisher Patrick Kiley, archivists Megan and Rick Prelinger, and artist Anne Walsh to reflect on the project. Throughout the production of *For Want of a Nail*, Futurefarmers held a "meta call and response" with a group of distant collaborators. During the artists' pilgrimage to the desert to search for iron and Trinitite, the phantom voices of these partners helped guide their inquiry into the human domination of nature.

The object that you hold in your hands reveals these phantoms and their reflections in the forms of texts, conversations, lists, and images. Fittingly, the form of this particular book presents a conundrum. In order to access these voices, the book form itself must yield to your dismantling. You may need a special tool to guide you in this process. We invite you to find your way into this work by force or hesitation. It is up to you.

CAST:
1. To give a shape to a liquid substance by pouring it into a form and letting it harden. 2. To consider; to turn or revolve in the mind; to meditate; to ponder; to plan. 3. To assign the parts of (a dramatic production) to actors. To assign (an actor) to a role. <was cast in the leading role> 4. To cause to move or send forth by throwing; <cast a shining lure>; to throw dice. 5. Direct. <cast a glance> 6. To put forth <the fire casts a warm glow> <cast light on the subject>; to place as if by throwing. <cast doubt on their reliability>

FORGE: 1. To form by heating and hammering; to beat into any particular shape, as a metal. 2. To fashion or reproduce for fraudulent purposes; counterfeit. <forge a signature> [F. *forge*, fr. L. *fabrica* workshop of an artisan who works with hard materials.] 3. To move ahead with increased speed and effectiveness. <to forge ahead>

RE-FUSE: re. again, e.g., re-reads. About, regarding, with reference to; especially in letters and documents.
Fuse: 1. To melt. 2. To become liquid. 3. To "blend different things," first recorded 1817.
Refuse: ([F. *refuser*, fr. L. *refundere* pour back, give back] 1. A rejected thing, waste material. 2. To renounce, to give up, to cast off. 12c.), from past participle stem of Latin *refundere* "pour back, give back." ca. 1300, from Old French *refuser* "reject, disregard, avoid." A rejected thing, waste material. To renounce, give up, to cast off.

# FORGING

Lucy R. Lippard

Hanging over my desk is a rusty, beat-up horseshoe with a couple of twisted flat nails sticking out. I found it somewhere in the once-working landscape surrounding the rural village of Galisteo, New Mexico, where I live. It's pretty old. When I moved here twenty-five years ago there were about seven horses on my side of the creek; now there are only two. Until the 1960s some villagers still got around on horses and in wagons, but common land granted by Spain and Mexico and degranted by the U.S. is no longer available for grazing. I hung the horseshoe arc-up until I was told that it should be hung arc-down so good luck can't fall out. A few miles to the northwest, as the crow flies, is the Los Alamos National Laboratory where Oppenheimer wanted a nail to hang his hat on (and where as a youth he rode horses while attending the Los Alamos Ranch School). Is this the horseshoe that for want of a nail ...? One thing leads to another, the way Futurefarmers mix and merge materials and memories.

No crow is flying today. Marvelously circuitous routes to outwardly simple conclusions are Futurefarmers's trademark. The serious play that sparks their projects leads the artists and their collaborators on intricate local and intellectual treasure hunts. They need a meteorite? Try ants, or an archaeologist. Coke being one of the preferred fuels for forging metals, they could have explored the nearby Waldo coke ovens that once worked coal from Madrid (pronounced *Mad*rid here in the provinces), now perceived as abandoned land art.

Aside from heating, hammering, or rolling metal, to forge also means to fashion, to fabricate, to contrive, to invent, or to coin (as in coin a term; and coin always underlies art these days), or even to fictionalize. More brutally, it means "to beat into shape." (Futurefarmers's trajectory has been gentler, cultivating consciousness rather than conflict.) I was taken by a dictionary reference to the signals given by blacksmiths to their helpers, registering "an ancient tradition." Forging of gold, silver, copper, and bronze was apparently first practiced in "prehistoric" Asia. (They had no history then?) African tribes were early experts in forging iron. There is something magical about a process that takes a material from red or white heat to cold water and births an object of beauty and/or usefulness.

A 1609 Christian Bible alludes to forgers who make "dumme idols," just like contemporary artists. A forger is both a maker and a faker, also at the heart of art making. (A female faker was once a *forgeress*.) But there is nothing fake about the actual process of making, even in its most dematerialized or conceptual form, Oppenheimer's table being another foil for Futurefarmers. Their process is expansive, transparent, and tricky. As their participatory operations suck viewers into place and history, the disconcerting focus on what initially appear to be insignificant details blossoms, blows up, forges ahead into unknown territory. Their "open practice" is based on exchange rather than imposition, enticing us out of our familiar cubicles into unfamiliar lands, even when we are already living there.

Their subject here is the micro/macro space, or distance, between the nail needed to hang Oppenheimer's hat and the nuclear bomb he was forging that was to change the world way beyond the Pajarito Plateau in the Jemez Mountains and Trinity Site on the White Sands Missile Range. That space was occupied by a great many people, from the military and the scientists to the innocent occupants of the distant state of New Mexico—which was awarded statehood only in 1912, thanks primarily to racism. Among those occupants: the mostly Hispano Los Alamos lab workers—who died unnoticed at such a rate that the Española Valley, where most of them

came from, has been called the Valley of No Grandfathers; and the mostly Hispano downwinders in the Tularosa Basin who have never been compensated for the cancers that still haunt their families.

The ramifications of that use of the Land of Enchantment were kept secret from these people and most U.S. citizens, as well as from the enemy. And the uranium, as the Prelingers explain elsewhere in this book, was dangerously unearthed in New Mexico's Four Corners area, home to contemporary Native nations that continue to suffer from that gamble, and to an infinite number of Ancestral Pueblo traces and ruins, a few of them brutal reminders of a past not always more civilized than our present. New Mexico, too often the poorest state in the nation, is a sacrifice zone, a military crucible. References to *forging* in Bartlett's *Familiar Quotations* are all about war. For instance, a poem by Percy Bysshe Shelley about early nineteenth-century inequity: "The seeds ye sow, another reaps / The wealth ye find, another keeps / The robes ye weave, another wears / The arms ye forge, another bears." *For Want of a Nail* makes us consider the manner in which things add up. History doesn't need to be about nostalgia.

It also makes us think, as so much of Futurefarmers's work does, about low and high technology, the resources needed to sustain the bombmakers and the artists, the lack of respect for (unprofitable) DIY solutions. As a more or less Luddite, living off the grid without some taken-for-granted modern amenities, I worry, as Amy Franceschini has, about a "Why the Future Doesn't Need Us" robot takeover, starting with the terrifying vision of self-driving cars. Warm-blooded animals wearing shoes nailed into their hooves to protect them, their riders, and related territories or investments are now too often restricted to those who can afford to feed them. Joy Harjo once wrote a poem about how horses make the landscape more beautiful, but during and after the 2008 recession many horses were abandoned to starve in New Mexico's beautiful, arid landscape. They have been replaced by the cold steel (or aluminum and Styrofoam) of soulless vehicles in a

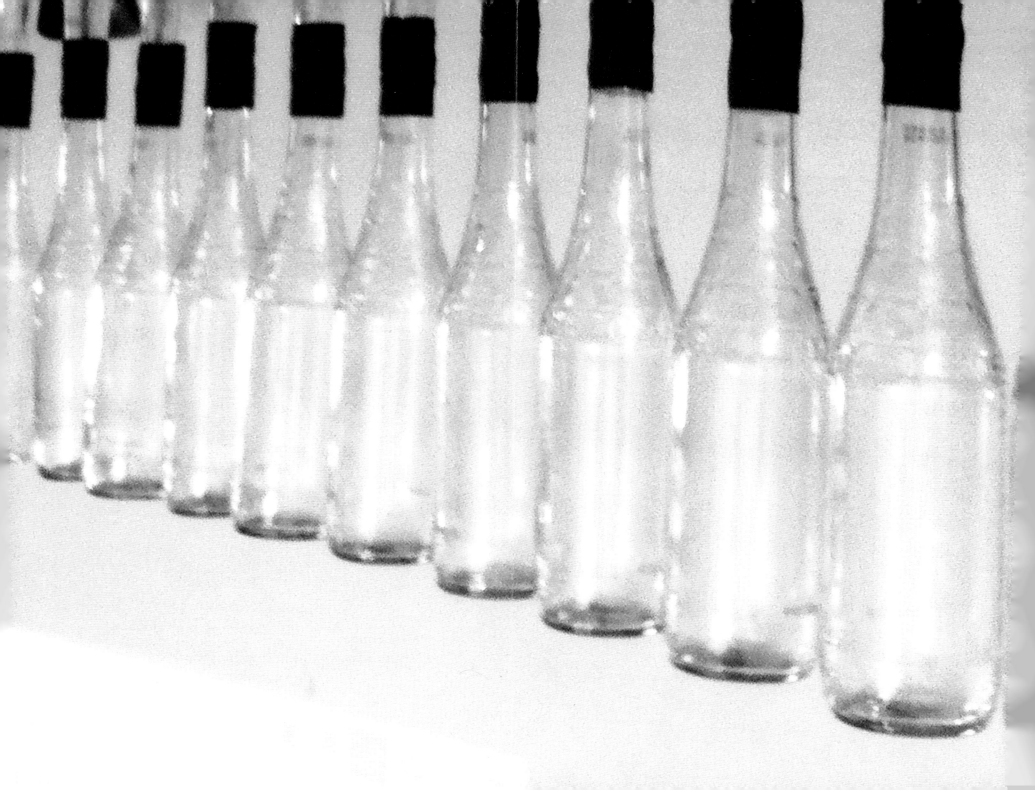

consumer-driven society. Aimless aggrandizement, growth for growth's sake, has become capitalism's unsustainable legacy. A nail that might once have taken down a nation has become a rusty artifact, resurrected, or restored to meaning here, by artists.

# REVERSE 20 QUESTIONS

### EXCERPTED FROM
Paul Davies, "The Strange World of the Quantum,"
The Ghost in the Atom

THE PHYSICIST JOHN WHEELER likes to tell a delightful parable which nicely illustrates the particular status of a quantum particle prior to measurement. The story concerns a version of the game of 20 questions:

Then my turn came, fourth to be sent from the room so that Lothar Nordheim's other fifteen after-dinner guests could consult in secret and agree on a difficult word. I was locked out unbelievably long. On finally being readmitted, I found a smile on everyone's face, sign of a joke or a plot. I nevertheless started my attempt to find the word. "Is it animal?" "No." "Is it mineral?" "Yes." "Is it green?" "No." "Is it white?" "Yes." These answers quickly. Then the questions began to take longer in the answering. It was strange. All I wanted from my friends was a simple yes or no. Yet the one queried would think and think, yes or no, no or yes, before responding. Finally I felt I was getting hot on the trail, that the word might be "cloud." I knew I was allowed only one chance at the final word. I ventured it: "Is it cloud?" "Yes," came the reply and everyone burst out laughing. They explained to me that there had been no word in the room. They had agreed not to agree on a word. Each one questioned could answer as he pleased—with the one requirement that he should have a word in mind compatible with his own response and all that

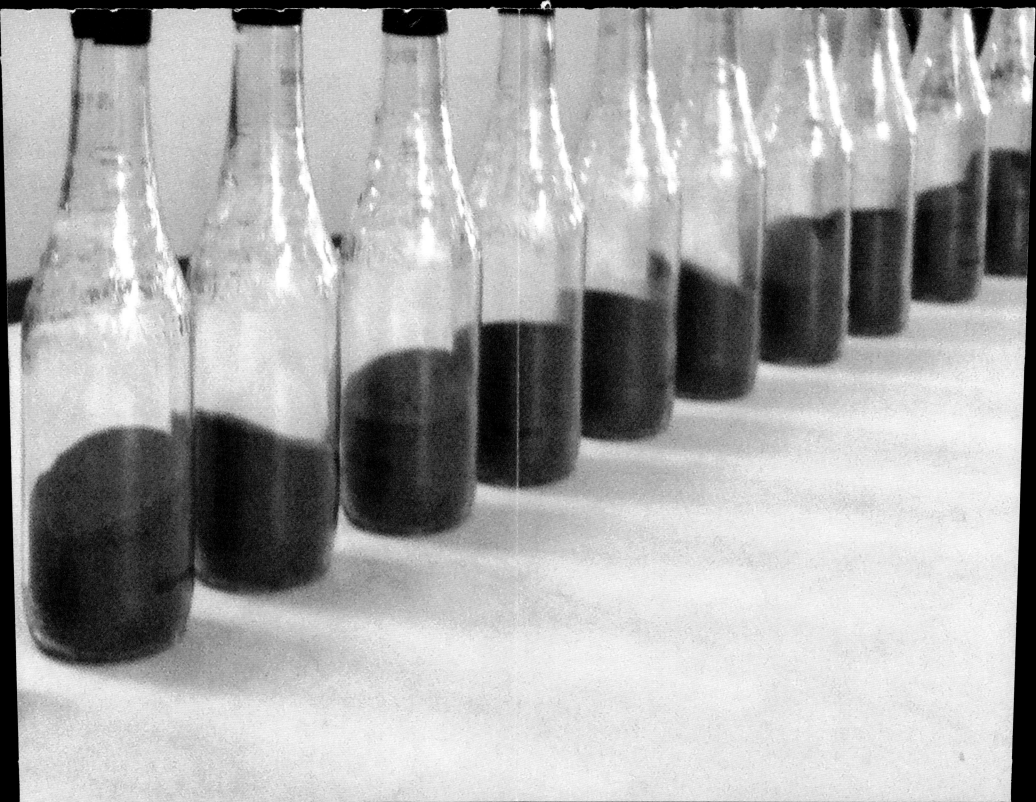

had gone before. Otherwise, if I challenged, he lost. The surprise version of the game of 20 questions was therefore as difficult for my colleagues as it was for me.

What is the symbolism of the story? The world, we once believed, exists "out there" independent of any active observation. The electron in the atom we once considered to have at each moment a definite position and a definite momentum. I, entering, thought the room contained a definite word. In actuality, the word was developed step by step through the questions I raised, as the information about the electron is brought into being by the experiment that the observer chooses to make; that is, by the kind of registering equipment that he puts into place. Had I asked different questions or the same questions in a different order I would have ended up with a different word as the experimenter would have ended up with a different story for the doings of the electrons. However, the power I had in bringing the particular word "cloud" into being was partial only. A major part of the selection lay in the "yes" and "no" replies of the colleagues around the room. Similarly the experimenter has some substantial influence on what will happen to the electron by the choice of experiments he will do on it, "questions he will put to nature"; but he knows there is a certain unpredictability about what any given one of these measurements will disclose, about what "answers nature will give," about what happens when "God plays dice." This comparison between the world of quantum observations and the surprise version of the game of 20 questions misses much, but it makes the central point. In the game, no word is a word until that word is promoted to reality by the choice of questions asked and answers given. In the real world of quantum physics, *no elementary phenomenon is a phenomenon until it is a recorded phenomenon.*

# THE STARRY MESSENGER

PETER GALISON IN CONVERSATION WITH FUTUREFARMERS

PETER GALISON: October 18, 1943.
FUTUREFARMERS: Yes. [BOTH MEMORANDA ARE READ ALOUD. PETER SMILES ... GLOWS.]

Those two documents were really our entry point into this project—into this meditation around the scope of the Manhattan Project. When we found these documents in the small historic museum in Los Alamos, we were amazed at the specificity of one detail of this very large endeavor.

PG: I had not seen these memoranda until you drew my attention to them. But there is something very affecting about seeing the dailiness of life at Los Alamos—what little survives around Trinity Site and White Sands Missile Range, what little survives from the Manhattan Project—about its everydayness and its minute material reality compared to the world of nuclear weapons that was being ushered in.

That new world involved not just the testing and then the detonations at Hiroshima and Nagasaki. Throughout the Cold War, many tens of thousands of nuclear weapons were fabricated by a growing number of nations. The main antagonists, the Soviets and their successors and the United States and its allies, produced and deployed thirty or forty thousand nuclear weapons.

The juxtaposition of scale, expense, destructive capacity, the destruction that actually occurred in the first atomic war—World War II—compared to the nail, a table, these little rooms, these markings, the little fragments of a life; this is deeply affecting. I think we are strange creatures to have the capacity on the one hand to see a couple of photons, and on the other to possess the ability to incinerate a city with a nuclear weapon.

That combination of sensitivity and brutality is moving … it is our human condition.

FF: The memos made us think about this "tool" of the atomic bomb that was being created by a huge cast of scientists and workers and involved the occupation of a large area of land. And we were driven to make this "nail" for Mr. Oppenheimer as a way of looking at our own tool set and ecology of collaborators.

We were in Santa Fe at the time, and we wondered, what type of nail would have been around in 1943? We imagined horseshoe nails, railroad ties … and wished to make a nail out of iron. But where would we get iron? We were pointed to state archaeologist Eric Blinman to ask where we might find iron nearby. Eric entertained our inquiry at his office (while he recruited us to help him make Yucca thread for a community workshop he was holding that weekend). Eric told us we could get access to old iron mines on Bureau of Land Management (BLM) land and collect remnants there, or he suggested that it might be more fun to take magnets out to the desert and fish for meteorite shards dusted upon the sand.

We were also taken to sculptor Tom Joyce's smithing workshop to see if he would forge the nail for us. But this seemed too precious.

We wanted to meditate on the idea of making a nail using a meteorite as the raw material and forging as the method to transform it. We chose to get a Canyon Diablo meteorite—a fragment of the asteroid that created Barringer Crater in Arizona. And in researching that crater, we learned that the asteroid that hit in Arizona fifty thousand years ago was the equivalent of 150 atomic bombs.

This particular meteorite happened to be very high in iron and nickel so it would work to forge into a nail. And there was something fitting about the meteorite being a (potentially) fifty-thousand-year-old material of unknown origin that humans once used to make tools.

PG: Almost since its beginning Los Alamos has been associated with the extraterrestrial—it seems to me no accident that Roswell and Los Alamos are close to one another.

Los Alamos was filled with people from far away—many with foreign accents—doing something so secret that they either would not discuss it at all or had to lie about it. Robert Serber remembers going to a local bar during the war to tell people that they were building something they weren't, in the hopes of creating a rumor that would distract people from the real secret, which was the atomic bomb. And people were recruited to work there without knowing what they were going to be working on, or even where they would be. That this was all associated with something extraterrestrial seems like a pretty natural connection to make. I mean, here is this making of a rock-sized thing that could destroy a city—did destroy two cities—and threatens to destroy many more. The secrecy, the power, the military, the war in which fifty million people died: it had all the elements to make people want to understand what they were forbidden from knowing. When people are presented with secrecy, they want explanations, and when they are not given explanations, they make them. It makes sense that what was going on at Los Alamos, which *was* associated with things outside town, state, and country, soon came to be thought of as reaching beyond the earth. One can look at it and empathize with people living around the site—with understanding and compassion for the disproportion of it all, and not mockery.

That is one thought that comes out of the juxtaposition of Roswell and Los Alamos: that the nuclear and the extraterrestrial have been intertwined in and among each other for the better part of a century.

There are other examples, too. The first gamma-ray bursts were discovered when people were trying to make satellites that could detect Soviet nuclear detonations on the far side of the moon.

In a way, the meteorite and the nail seem to go together in a rather natural way. Meteorites are messages … material messages from a faraway place. I mean, we believe that all the higher elements in the periodic table were formed in explosions of stars far away. They are not primordial, they are not from the big bang—only the lightest elements are from the beginning of the universe—they are from the moment of stars creating supernovas. Most of our bodies are made from the dust of dead stars.

It is interesting to think about the scale of time. Something that is practically infinite in comparison to our lives is but a mere heartbeat in

the history of the world. Almost all of the plutonium we encounter is made by us. For although twenty-four thousand years — the half-life of plutonium — is very long compared to human civilization, it is very short compared to the age of the earth or the solar system or the universe. Ten half-lives is only 240,000 years and the earth is 4.5 billion years old and the universe is 13.7 billion years old, so whatever plutonium was formed in supernovas or in the formation of the earth is long, long gone.

FF: Can you meditate for a moment on the process of forging this meteorite?

PG: So, you made three nails: one from meteorite, one from Trinitite, and one from coin. I think those are beautifully chosen in the sense that they each represent such different parts of our world.

Each of these nails you made has a different aspect — one is long before us and beyond our comprehension in terms of origin, and one is made from the heat of the explosion of the atomic bomb. One is created out of a material that was employed for the war. Steel nickels were used to free up nickel urgently needed to separate uranium 235 from 238 to make atomic bombs (no one outside the project knew that that was the purpose back then). That was what all that nickel was needed for … "war coins."

A story occurs to me, I don't know if it was Trinity Site or another nuclear detonation site. A general was brought in to see the site. The physicists looked at this glassy surface that extended hundreds of yards around it and to them it was the sign of unimaginable power and destruction: the blast had been able to fuse sand for hundreds of yards. But the general looked at this flat area of glassy sand and said, "Is that all you got? Is that all that this is?" It struck me as emblematic of people looking at the same thing; they all had clearance, but it just signified differently. The general was looking at the torn-apart building, while the physicists saw Trinitite itself as evidence of extremely high temperatures able to fuse sand out to a good distance. … Even looking at the same thing, people *see* differently.

I think the idea of these three nails speaks to the allusive quality to this war work and the atomic bomb as starry messenger, to crib a term from Galileo.

FF: In thinking about this complicated history of the Manhattan Project and the paper trails connected to all of the information

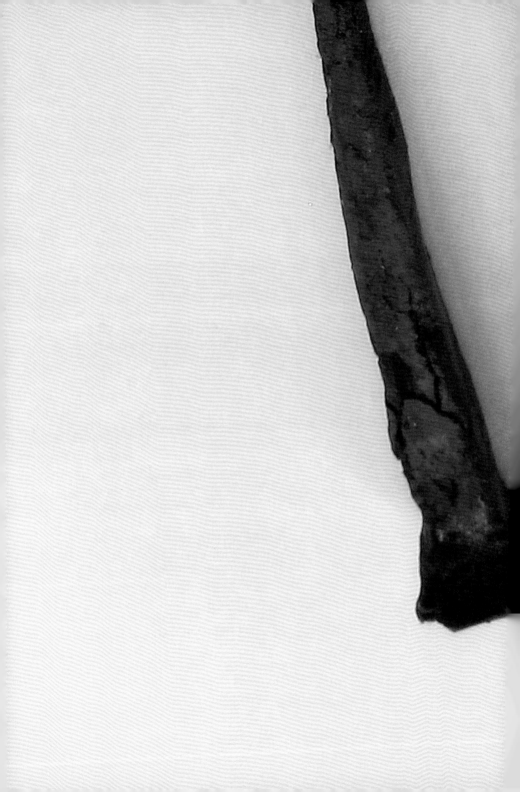

flow—for example, the process of this information being classified and then declassified—are there parts of that story that are still unexplored?

PG: The first time I looked at declassified documents it had a huge effect on me. I had grown up from a very early age loving physics. Physics was something that I thought was indescribably beautiful. My great-grandfather had worked in Edison's laboratory, and I knew *his* laboratory because he lived almost to one hundred. I looked at his double-pole, double-throw switches and bottles of mercury and arc lamps. To me the materiality of physics and electrical engineering were just magic. And I loved what I learned as a teenager about relativity and what it said about space and time. It seemed wondrous.

Much later, when I moved out to California to teach at Stanford and I was going down to Los Alamos and using their archives, I was struck by the way in which the same kind of calculations, which to me were the very fabric of physics, were being used to calculate bomb destruction radius—the alpha and omega of war. It was a real shock to me. … It is not that I did not know; I taught about the atomic bomb and of course I knew about these things. But, somehow, seeing the calculations—not the description of people remembering the comradery or the frustrations or the ambivalence at Los Alamos, but just that everydayness of the tools—seeing the way in which suddenly these variables $x$ and *lambda* and *alpha*, these derivatives and integrals, these elements of everyday calculation, were being used to destroy cities … well, it really shook me. And I was surprised that it shook me. Even at the time, I felt, "of course you should know that."

It made me also think of Robert Wilson at the end of the war. He describes in the film *The Day After Trinity*—a great film by Jon Else—how after the announcement of Hiroshima they had a party to celebrate the end of the war. He was so upset at what had happened that he threw up in his wastebasket, and you sort of think to yourself, "You were working on the atomic bomb, what did you think was going to happen?" But it is one thing to think and another thing to know that something has become a reality. And on an infinitesimally smaller scale, I think that is something of what I felt when I saw these tools of thought as part of making the weapon.

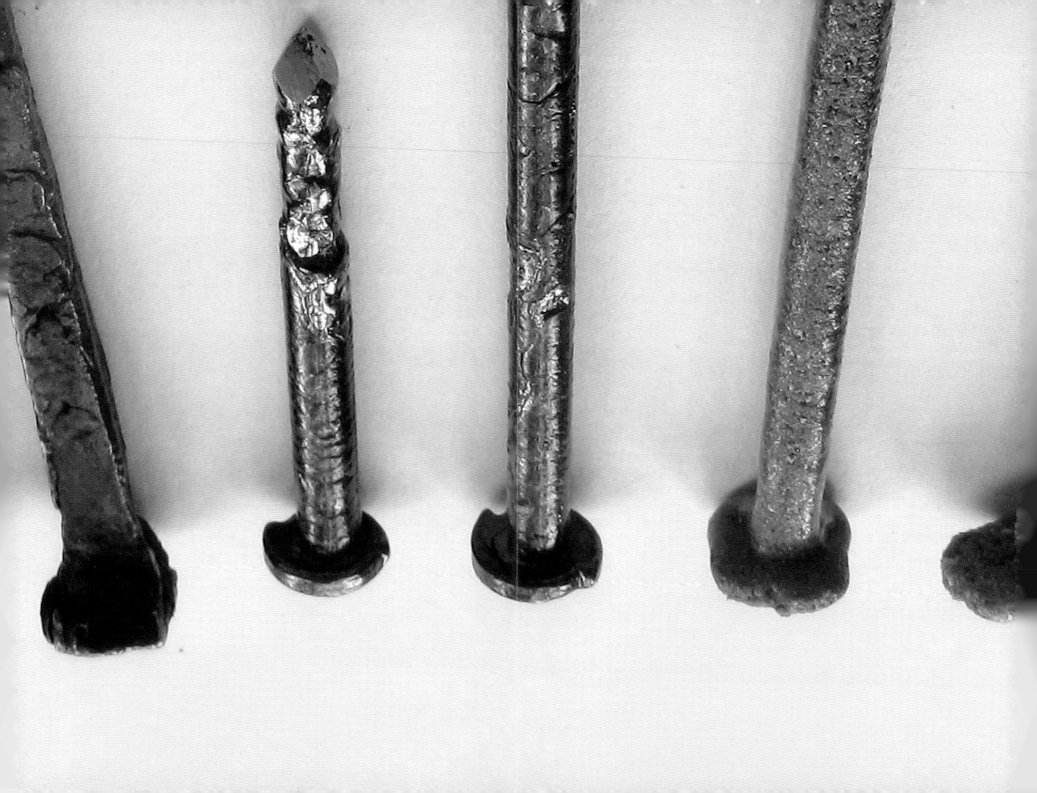

I think something similar is behind some of your questions as artists/thinkers. What are tools? And could the fused sand created by an atomic bomb be turned into a nail? What does it mean to repurpose this material? ... Things go in all different directions.

This everydayness, this quotidian aspect that cycles between things that we think of as impossibly opposite, whether they are the integral or a derivative or a nail or a life jacket that was first tested in concentration camps and now saves people's lives. Things move back and forth in our world and connect things that we don't always like to think of as connected.

FF: What kind of constraints are there on the kind of weapons or scientific work that is done today?

PG: One of the things that happened in the Cold War around 1954 was what was called the Trial of J. Robert Oppenheimer, which resulted in a bifurcation of the scientific community that had not been there before—into a "weapons world" and a "non-weapons world." Now, there are some points that still overlap, but in World War II, that division wasn't there. The major people on the Manhattan Project were some of the great civilian scientists of the twentieth century—Oppenheimer and Teller, Bethe and Feynman—who made weapons during the war and then afterwards went back to not making weapons, to doing fundamental research ... Enrico Fermi, for example.

In 1954, the government became very suspicious; they did not like that the civilian scientists were making such a fuss about building the hydrogen bomb. It was really a big debate that split the scientific community. Half of the scientists said, "Don't build the hydrogen bomb, the atomic bomb is powerful enough," and half of them said, "You have to build the hydrogen bomb or else we will end up losing the Cold War and Europe." The Atomic Energy Commission commissioners concurred with the dissenters, saying, "Don't build it!" and it went all the way up to President Truman. That tortured contemplation of weapons and ethics was entirely foreign to Truman, who simply decided, "Of course, you should build it." The result was real suspicion from the Air Force on down through the other military and civilian branches of the Atomic Energy Commission. They did not want to be pulling the rope one way when scientists were pulling the rope the other way, and they did not want to worry about

countervailing publicity, articles, and speeches from within the weapons establishment. Bethe, for example, went on Eleanor Roosevelt's television show and said, "This hydrogen bomb is a weapon of genocide." The government simply did not want to deal with that kind of internal resistance anymore. It led to a fundamental separation between the civilian and militarized scientific sectors.

Bottom line: You had dueling apocalypses; there were those that thought this thermonuclear device was inherently a weapon of genocide and those that thought that not to build it would be to concede the Cold War, Europe, and freedom to the Soviets—to Stalin. That level of discussion was at least a partial constraint on what could be built. I mean, it slowed it down, but it did not stop it. But it was definitely a moment to pause in the helter-skelter race for more advanced weapons.

But once the division is internalized ...

[The light in Galison's office goes off and we see darkness on the screen. He turns the light on, "The automatic lighting system thinks I am dead or gone if I don't move."]

... once there is a kind of hermetically sealed weapons community that is separate from a hermetically sealed civilian community, there is less of that back and forth.

Perhaps this is a slight exaggeration but as a result of the struggles from 1949 to 1954, the great civilian scientists of today (on the whole) are not building weapons. The major weapon designers are (on the whole) not contributing fundamentally to civilian physics. Now, there are some areas of overlap, like star formation ... where the physics of something very interesting only to civilians actually has a lot of overlap to what goes on in the hydrogen bomb. So, there is some connection. And there are very powerful computers that can be used in both areas. But in the main, compared to what happened at the time of the Manhattan Project or the early Cold War, they really become two separate communities with their own rules and regulations, dynamics and controls ... and their own rewards, publications, advancements, jobs, etc.

FF: There is an anecdote from John Wheeler about something called "Reverse 20 Questions." It stems from the game "20 Questions," where you go into a room with a bunch of people

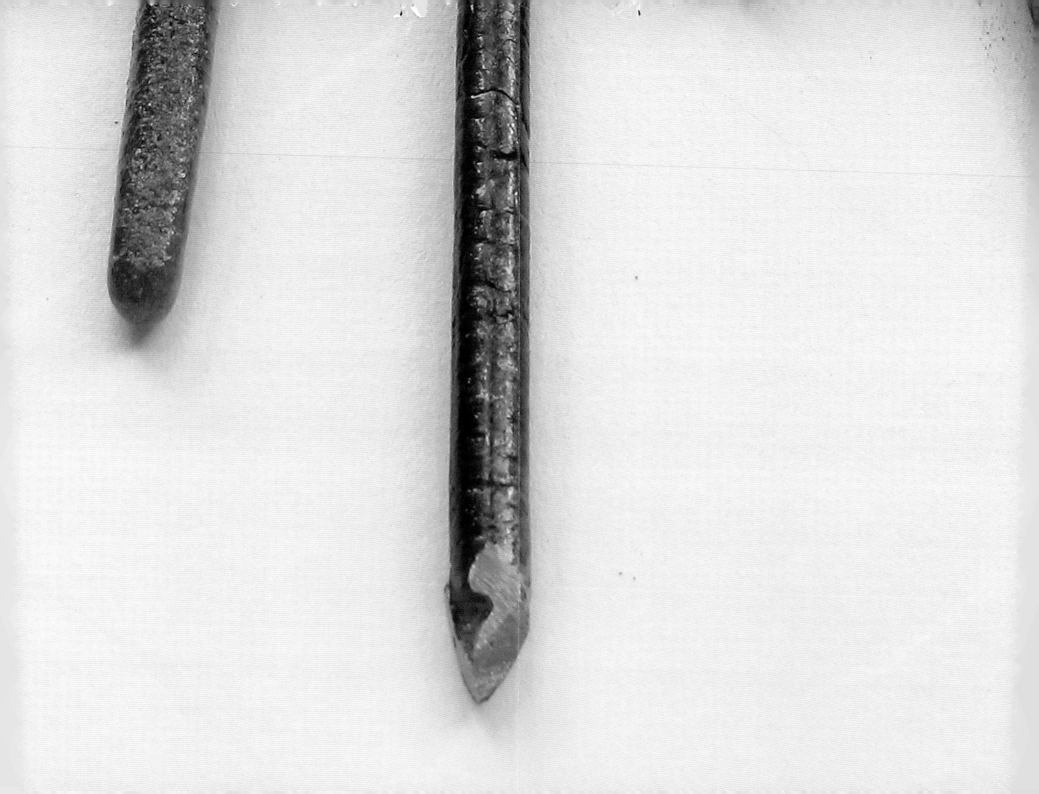

who have all agreed upon an object (let's say, an elephant), but you do not know what that object is and you get twenty yes-or-no questions to guess. You ask, "Is it bigger than a bread box?"… and you slowly narrow down the possibilities within this twenty-question limit.

John Wheeler describes that he was once at a party, and the guests couldn't agree on an object, so they agreed not to agree. The only rule of "Reverse 20 Questions" is that after one person answers a question, then everyone else in the room has to shift their thing to fit with the previous answers, so that the entire room of yeses and nos determines what object is formed.

In Wheeler's account, he describes a cloud being produced at the end, and they all agreed that it had to be a cloud even though no one was thinking of a cloud in the beginning.

For us, this anecdote points back to this idea of consequences—that our questions and the answers we set up might lead to something we might not know about.

PG: Well, I knew John Wheeler pretty well, and I really adored him. [Sound of someone knocking at Peter's door. He moves away from camera and returns. "Someone was here to speak to me about a center I started for the study of black holes with five of my colleagues—physics, philosophy, mathematics, history, astronomy, and astrophysics. It's the Black Hole Initiative—rather appropriately for this moment since it was John Wheeler who made popular the name "black hole"!]

Wheeler loved to locate paradoxes, impossibilities, and the crisis in physics. And I think it goes back to autobiographical interests he had—he was always interested in explosions. He lost a piece of his finger playing with a dynamite cap when he was a kid. But I think more broadly, he worked with Niels Bohr at the founding moment of quantum mechanics. He was one of those young Americans who went to Copenhagen in those very early years, in the 1930s. He was, like many people, enormously taken by Bohr's interest in contradictions and crises as being generative of a new way of thinking about the world—which quantum mechanics was.

Paradoxes like how can an electron go around a nucleus and not fall in led to Bohr thinking about these stationary orbits and quantum

theory and then the contradictions between waves and particles, which eventually led to quantum mechanics. He always loved that, and Wheeler came back to this idea of crisis many times in his life—about quantum electrodynamics, about black holes, about the end of space and time—he called the coming together of the formation of these singularities the *greatest crisis of physics*. He loved throwing things into consideration that otherwise remained unquestioned.

I think that idea of having people form a new kind of questioning or asking the right question of the world and putting aside what they originally thought—as through the "Reverse 20 Questions"—corresponded to the way he thought about science, and I think he learned that from Bohr. Bohr was asked once why the way people worked on quantum physics was so different from the way people worked on relativity, and he said, "Einstein could basically do relativity by himself. It was a solitary affair, especially general relativity—he had a few students who helped him with some of the math, but basically it was a single author creation, whereas quantum mechanics from the get-go was a very collective, social enterprise." They fought, they quarreled, they collaborated, and Bohr almost never wrote things down by himself, he had amanuenses. Sometimes his wife and his secretary and sometimes his students wrote, but everything was constantly being reworked and rethought by others, including Heisenberg and Schrödinger. Wheeler experienced the world as a socially produced dialogue that was constantly refining and looking for better ways of asking: "how could I produce something that asks the question in the right way?" So, in a way, Wheeler turning to "Reverse 20 Questions" makes sense to me as reflecting something deep about the way Wheeler liked to think … with others.

FF: We are working with Geoff Kaplan to design this book, and he decided to make the book uncut. When all the folios are bound together, the last step is usually to cut the edges of the book and, in a sense, open the book up. He thought there was something beautiful about an uncut, unopened book.

PG: Yes, you open it with your paper cutter and cut the pages yourself … old school.

FF: We will make a special edition that will include a special tool for opening the book.

PG: I used to love that in France when I was growing up. I read a lot of French literature, and I adored the preparatory ritual of taking out my special paper cutter and opening the pages.

FF: In relation to the form of this book, there is something that relates to the idea of "top secret" and our idea of hesitation— making the reader of the book hesitate because the reading of the book is not simple or easy. The reader will have to be confronted with this tool and take action to read the book.

PG: Tools for reading!

FF: We will use a petrified tree from New Mexico. They will be core samples of the tree with one side sharpened, so it will look like an old stone tool with little rings that you can see. The title of the book is *For Want of a Nail.*

PG: When I first saw your project, I thought about to what extent these little things cascaded into a big thing. The original story about the nail and the horseshoe and the horse and the battle—they are all conditions of possibility for the next stage in the argument. But there is another relationship of particulars and the everyday to the larger world, and that is something being emblematic or containing within it an image of the larger whole. One sets up a causal or conditional relationship—you know, the nail, horseshoe, horse, battle, kingdom. But I am more interested in another relationship, the kind that doesn't suggest that the atomic bomb would not have been built if Robert Oppenheimer didn't have a place to put his hat, but rather that these little things carry a kind of microcosmistic imprint of the larger.

A lot of the work that I do—whether it be on Einstein's clocks or Poincaré's maps or on the images of objectivity, instruments in particle physics, secrecy, or containment—stems from my interest in the material embodiment of big philosophical things, the sudden juxtaposition of the specific and the abstract, the material and the abstract.

I tend to think of this as having three parts: One is that materiality helps us understand the general or the large or the abstract—because often abstract arguments are really about something specific. They have their origin in a specific debate, as, for example, when someone comes in and says, "I can't stand the idea of collectivization of property," and it turns out they are talking about their grandfather's loss of his farm. Frequently abstraction can obscure our understanding,

and arguments are better understood, whether they are scientific arguments or political or philosophical arguments, in the specificity and materiality of the thing that is actually the core of what is going on. I think that we obscure specifics in a desire to be general (as if it were somehow better), but it actually makes explanation harder.

Connected to the explanatory is a political question. One of the reasons that I make films is because, when dealing with things like secrecy or containment, it is easy to think of them as nowhere, or elsewhere. Secrecy is just something out there in a universal darkness ... and nuclear waste, who knows where that is? It lies in our mind's eye somewhere else. In someone else's state, somebody else's country, somebody else's land. Materiality helps make possible an understanding of some of the big political issues that are connected to technical questions. Here, in the southeast corner of New Mexico, lie million-gallon tanks with highly radioactive sludge thick like peanut butter. *That* is something we can imagine, and that might prompt us to consider it in making our political judgment and plans.

It is easy to say, *who cares about privacy or who cares about secrecy or surveillance ...*

But it is only when those things are materialized and specified that the conditions are there for people to engage in a political argument around technical things, and I think in many ways those arguments are the start and finish — the future of democracy. How we are going to have those arguments and how, in their absence, privacy, secrecy, and surveillance remain abstractly legal or moral, philosophical or political, rather than something that doesn't urgently intersect with ordinary, everyday life.

And the third thing is that philosophically it seems really interesting to me to understand those moments where very material and very abstract things collide. Like what time is ... and that Einstein might have actually been thinking about patented coordinated clocks along railway lines when he said, "What if you had coordinated clocks?" or that Poincaré might have been thinking about making maps when he started talking about maps. I think there is something rather deep about thinking about the relationship of the abstract and the concrete together, rather than starting with the most abstract parts of physics and then imagining they are "applied." We picture

all too easily (and wrongly, I believe) that things always start in the stratosphere of abstraction, eventually becoming something you do in a laboratory and bring to an engineering firm, factory ... and that is how you got your iPhone.

Or the opposite: the Platonic idea where you start from a triangle drawn in the sand that becomes a triangle drawn with a thin pencil, and then it becomes a shadow on the wall of the cave, and eventually it is something only in the mind's eye — and that's when you have gone from the purely material to the purely abstract. Instead of the ascent or the descent, I like to think of these things as slammed against one another: a direct juxtaposition of the all-too material and the stunningly abstract.

I bring this up because for me understanding big things in their abstract and moral, ethical, political, philosophical form often requires at the same moment understanding the very material—the nail or the Trinitite ... the heat of fusion.

*FOR WANT OF A NAIL*

*THE STARRY MESSENGER*

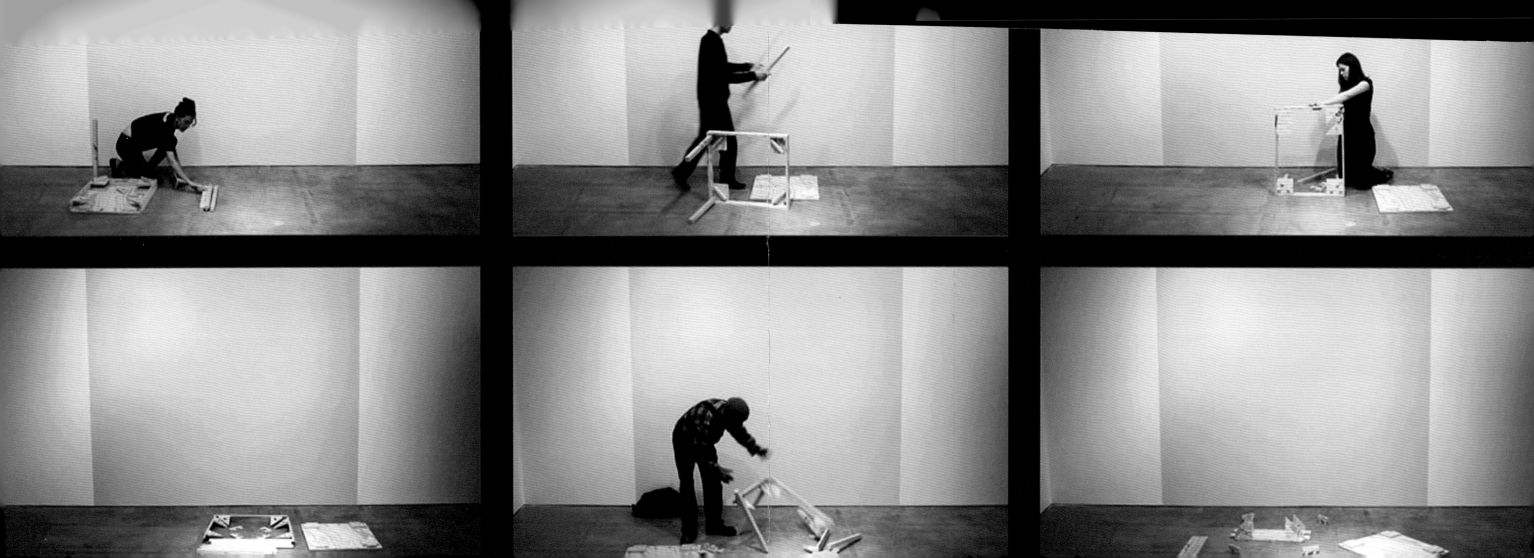

# THE PROSPECTOR'S TOOL LIBRARY

MEGAN PRELINGER AND RICK PRELINGER

---

I.

---

In the mid-1950s, the landscape of the desert Southwest, particularly the Four Corners area, was animated by a fast-developing culture of amateur uranium prospecting. Fueled explicitly by demand from the U.S. Atomic Energy Commission, this prospecting boom was also fueled implicitly by a mainstream American cultural fixation on "frontier" prospecting, and excitement over a new mineral boom that promised riches, and was best engaged on foot, horseback, or in a four-wheel-drive Jeep on unfenced desert lands. For Native people on whose lands the boom rode roughshod, the public rush onto uranium-rich desert lands can only be seen as an unexpected extra insult. The functional end of the nineteenth-century frontier had already taken place with the mapping and territorial allocations of the public lands of the western states. But when the AEC began urging citizens to go find uranium-rich yellowcake, the result was a disorganized rush for the new "gold" of the uranium ore, centered in Utah, Colorado, Arizona, and New Mexico.

To explore the tools and language that were developed for the uranium prospecting era, we turned to the trade periodical *Uranium* magazine. To find pictures of people engaged in prospecting, we mined footage from a sponsored film, *Prospecting for Uranium*, showing families incorporating prospecting into a hybrid situation of frontier exploration and family fun. The tools developed to support the new prospecting culture often

Scoot-Crete Ore Carrier (Getman Brothers)
Snooper Geiger Counter (Radio, Inc.)
Super Pioneer Diamond Core Drill (Diamond Drill
    Contracting Co.)
Syntron Gasoline Hammer Rock Drill (Syntron Company)
Uralarm (Research, Inc.)
Urani-Tector Uranium Kit (CMG Industries)
Victoreen Thyac (Victoreen Instruments)
Victoreen Vic-Tic (Victoreen Instruments)
Wedgie Radiation Detection Instrument (Scintillonics, Inc.)

Airline: Frontier Airlines. "Fly and Ship Frontier to
    the New Uranium Country"

### 4. SELECTED NAMES OF MINES AND MINING COMPANIES LISTED IN *URANIUM*, VOLUME 2 (1955)

ATOMIC Claims, Blanding Area, Colo.
BIKINI Uranium Corp., Pocatello, Idaho
FREE ENTERPRISE Mine, Boulder Batholith Area, Mont.
HOLY TERROR Mining Co., Keystone Area, South Dakota
HORSESHOE Mine, Lisbon Valley Area, Utah
    (re: "For want of a nail ...")
HOT ROCK Claim, Lisbon Valley Area, Utah
MOONBEAM Mine, Long Park Area, Colo.
MOONLIGHT Mine, King's River Area, Nev.
RED FLASH, Incline, Bull Canyon-Gypsum Valley Area, Colo.
RADON Claim, Lisbon Valley Area, Utah
RADIUM CYCLE Mine, Lisbon Valley Area, Utah
RADIUM GROUP, Black Rock Area, Colo.
RADIUM HILL Claim, Bull Canyon-Gypsum Valley Area, Colo.
RADON Claim, Lisbon Valley Area, Utah
STARLIGHT, Bull Canyon-Gypsum Valley Area, Colo.
TEAPOT DOME Mine, Bull Canyon-Gypsum Valley Area, Colo.
VANADIUM KING Mine, Long Park Area, Colo.
VANURA Mine, San Rafael Swell Area, Utah

# CASTING CALL

MAY 18, 2014

TEN ACTORS BUILD THE TABLE DESCRIBED IN THE INTER-OFFICE MEMORANDA SENT FROM J. ROBERT OPPENHEIMER'S OFFICE.

INSTRUCTIONS
TO ACTORS:

ENTER STAGE LEFT

ASSEMBLE A TABLE FROM THESE PARTS

TAKE APART TABLE

EXIT STAGE LEFT

NEXT ACTOR ENTERS

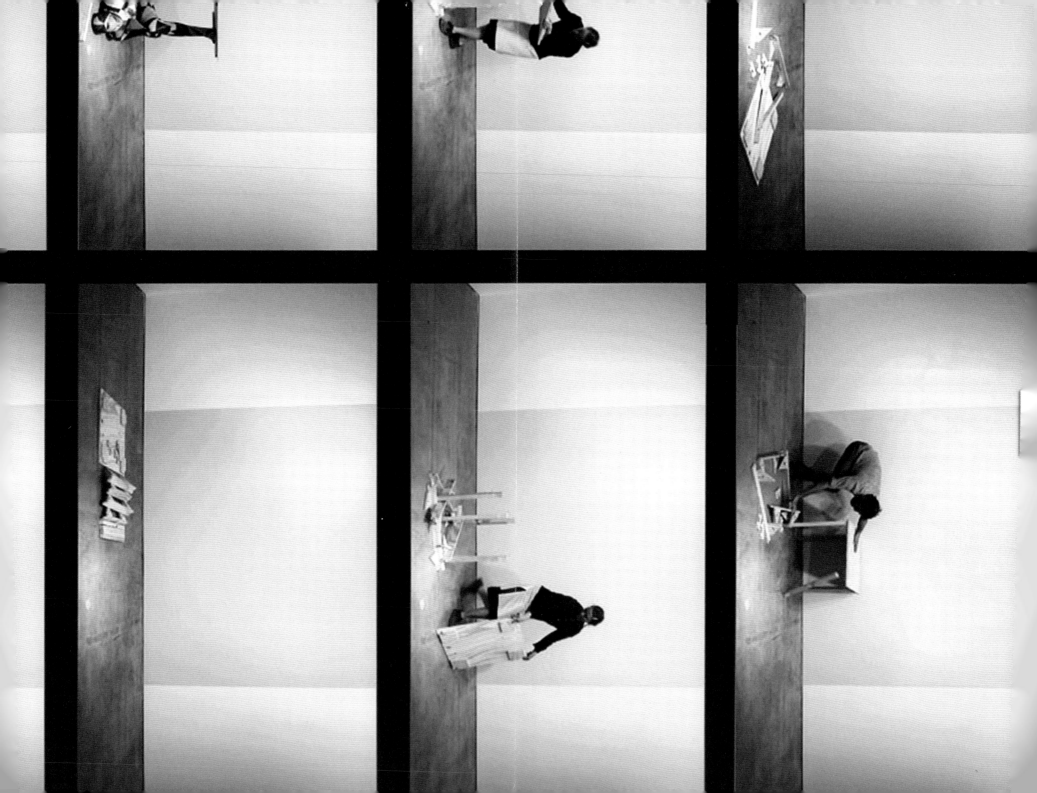

referenced legacy "frontier" cultural markers, yet they also expressed that the mid-1950s were *not* part of the nineteenth century: In language found in the pages of *Uranium*, the frontier meets midcentury modern, with names of products and projects that are portmanteaus of technophilic lexical elements like "-tron" (from *electron*), and words like *vector* and *detector*, grounding the frontier landscape exploration in the science-based framework of the atomic era. *Prospecting for Uranium* is available at Internet Archive, and *Uranium* is available for browsing at the Prelinger Library.

## 2. Prospector's Tool Library

Basic equipment: picks; maps of uranium deposits; kits to stake claims; Geiger counters (audio display of radiation readings); radiation instruments such as hole probes; scintillation counters (visual display of radiation readings); drills, rock drillbreakers; "x-ray" diamond drill to extract cores.

## 3. Prospecting tools advertised in *Uranium*
### (volumes 1 and 2, 1954–55),
#### listed alphabetically by name order,
#### with manufacturer name in parentheses

Arcotron Scintillation Counter (Atomic Research Corp.)

Bismatron Scintillation Counter (Atomic Research Corp.)

Bismo-Count Scintillation Counter (Electronic Counter Laboratories)

Blue Demon Insert Rock Bits (Herb J. Hawthorne, Inc.)

Brunton Pocket Transit (Wm. Ainsworth & Sons, Inc.)

Claim Striker Supersensitive Geiger Counter with genuine saddle leather carrying case and shoulder strap $10 extra (Perfecto Radiation Instruments, Inc.)

Countmaster (Hoffman Laboratories, Inc.)

Cryderman Shaft Mucker (Cryderman)

Crysto-Count Scintillation Counter (Electronic Counter Laboratories)

Detectron Airborne Scintillation Survey Meter (The Detectron Company)

Detectron Scintillater [*sic*] (The Detectron Company)

Electro-Count (Electronic Counter Laboratories)

Fisher Count-O-Scope (Fisher Research Laboratory)

Geigerscope Uranium Radioactivity Detector (Ken Research Inc.)

Geologist Scintillation Counter (Scintillonics, Inc.)

Interceptor High Efficiency Radioactive Ore Detector (E. R. Vinson Company)

JAco Fluorimeter (Jarrell-Ash Company)

Longyear Porta Core Drill (Western Machinery Company)

Lucky Strike Geiger Counter (Radio, Inc.)

Micro-Scint Lode Star (General Nuclear Co.)

Mineralight (Prospectors Supply Co.)

Mini-Scint Lode Star (General Nuclear Co.)

Miracle Geiger Counter (Universal Atomics Corp.)

MLE Mark I Geiger Counter (Modern Living Electric, Inc.)

National Radiac Aerial Scintillation Counter (National Radiac, Inc.)

New Royal Scintillator (Precision Radiation Instruments, Inc.)

Nucliometer (The Detectron Company)

Oracle Model 2613 (Nuclear-Chicago)

Ore-Lokator (Nucleonic Company of America)

Oremaster Super Geiger Counter (White's Electronics)

Pioneer Geiger Counter (The Gaertner Company)

Precision Percent Meter Geiger Counter (The Geiger Center)

Radiassay (Applied Research Co., Inc.)

Radiation Scout (Scintillonics, Inc.)

Radiation Vector Meter (General Nuclear Co.)

Raytomic Arcotron (Atomic Research Corporation)

Raytomic Super-X (Atomic Research Corporation)

Scinta-Ray Portable Scintillation Counter (The Goldak Co.)

Scintilla-Dyne (Fisher Research Laboratory, Inc.)

# CASTING CALL:
Leading Role in Short Film (To be screened at SITE Santa Fe)
$300*

# AUDITIONS: May 23, 2014
*Where: SITE Santa Fe, New Mexico
11AM—5PM
(Snacks Provided)

*1606 Paseo de Peralta, Santa Fe

Seeking:
Mr. X to perform a scene involving a search for iron in the
Jornada del Muerto Desert. This will be a one-day video shoot
in the field on May 26th, 2014.
The site will be outdoors in the sun.
(Sunscreen and hats will be provided.)

Mr. X
Thinks about the universe all the time.
He organizes many people around him.
They circle around him like he is the sun.
Smokes more than he should, but was from a generation in
which ... he often wore a hat.

# CALL 505 989 1199
Deadline: March 14, 2014

*The audition will be video taped and used in an exhibition
at SITE Santa Fe. If you come to this casting call and agree to
these terms, you will be paid a $50 fee for the audition. If you
are chosen for the role, you will be paid an additional $250.

You could, for instance, consider casting non-living individuals to play JRO. How you would manage this technically is not obvious, but those historical figures' names in the film credits would communicate a great deal. Is a <u>human</u> actor required to portray me? I wonder, for example, if an institution or concept would work just as well. Following from these relaxations in the practice and understanding of "realism," one could imagine other choices for JRO: surely race and gender are no longer so fixed as to demand a white male of Ashkenazi descent. Why not cast a person whose spirit, reputation, or intellectual endowments are like my own, regardless of their genetic identity? Why not cast multiple actors? Shiva, you know, was a deity with many aspects. Your fellow Todd Haynes made a splendid study in public persona with his film "I'm Not There," wherein the American musician Bob Dylan is played by six actors, one of whom I see now and again. Well, I'm not there either. I'm everywhere.

The list I submit to you here includes names you undoubtedly will recognize. Some you may not: the visual arts, sport, literature, political activism, philosophy, popular entertainment, and computer science hold equal standing in this pantheon. Brilliance, goodness, and conviction are all that is required. All casting is type-casting, after all.

May the longtime sun shine upon you. Please call upon me should you find yourselves in need.

DAVID BOWIE
MARCEL PROUST
CHELSEA MANNING
EDDIE MURPHY
PAUL REUBENS (AKA PEE-WEE HERMAN)
JUDITH BUTLER
MR. ROGERS
MAX ERNST
MATIAS VIEGENER
PAUL ÉLUARD

# NOTES ON CASTING

Anne Walsh

To: The Futurefarmers, Amy Franceschini and Michael Swaine
From: JRO
Re: Casting notes 1/3
Date: 10.02.2017

While you have not directly solicited my participation, I under-
stand you are the producers of "For Want of a Nail: The Movie."
Up to this moment, I have held my peace where biography was
concerned. Enough with misunderstanding. Likewise, enough
with defending myself. Of course you are under no obligation
even to read the following, however it is in my nature to spec-
ulate upon casting which might produce a nuanced and rich
depiction of my "character."

I can well imagine that your Casting Director already has
specific notions for whom to cast as JRO. (Certain individuals
come quickly to mind, and I should not be surprised nor even
disturbed to see names such as Adrien Brody, Paul Reubens, or
Bradley Cooper at the top of a casting director's list.) Physical
resemblance is often a prerequisite for convincing portrayals
of historic individuals. After all, the world does know how I
looked; a hat and cigarette or a gaunt, stooped figure will not
suffice to render "JRO." The film is yours, of course, however I
should think audiences might be morally aroused and intellec-
tually provoked by certain unconventional approaches. Long
live the avant-garde.

EDDIE REDMAYNE
COLIN KAEPERNICK
JEAN ARP
TILDA SWINTON
PAUL REISER (FROM MAD ABOUT YOU)
ALICIA VIKANDER
BEN STILLER
MICHAEL PENN
JOAQUIN PHOENIX
DERAY MCKESSON
STEVE MARTIN
KHAN ACADEMY
DAVID GRAEBER
ADRIEN BRODY
BRET VICTOR
HAYAO MIYAZAKI
SCHROEDER (PEANUTS)
OSCAR WILDE
HELEN KELLER
GEORGE C. SCOTT
JOHNNY ROTTEN
WIZARD HOWL
SARAH JESSICA PARKER
DAVID BECKHAM

IMAGE 9
PRODUCTION STILL FROM *Coin Toss*, 2014

From ten miles away, we saw the unbelievably brilliant flash. That was not the most impressive thing. We knew it was going to be blinding. We wore welder's glasses. The thing that got me was not the flash but the blinding heat of a bright day on your face in the cold desert morning. It was like opening a hot oven with the sun coming out like a sunrise.

—Philip Morrison, Manhattan Project scientist, on the first atomic blast

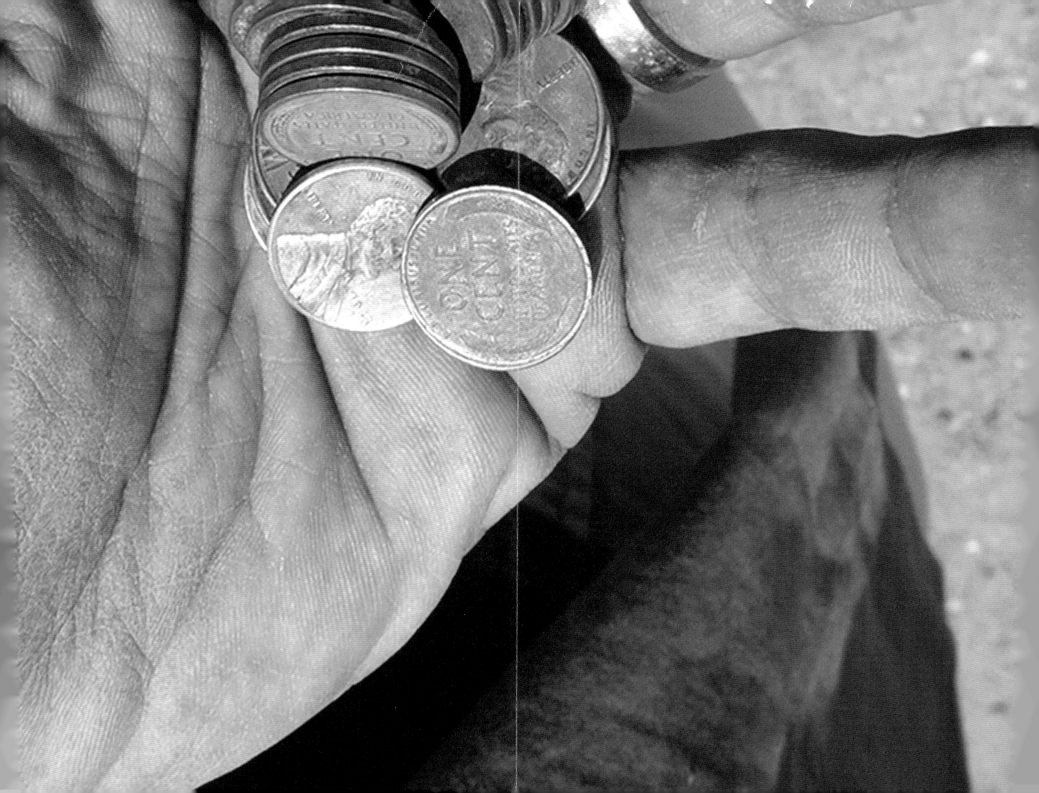

SALMAN RUSHDIE
CHARLOTTE CORDAY
SPIKE JONZE
STEVE JOBS
ALAN TURING
JEAN-PAUL BELMONDO
LIN-MANUEL MIRANDA
SARAH SILVERMAN
HOWARD ZINN
JODIE FOSTER
GEORGE ORWELL
SEAN PENN
JEAN-PAUL MARAT
DIANA, PRINCESS OF WALES
ROGER FEDERER
FRANZ KAFKA
MATTHEW KOPKA
JARED KUSHNER
EDWARD SNOWDEN
JOHN CAGE
BRADLEY COOPER
LADY GAGA
TIM BERNERS-LEE
DAVID FOSTER WALLACE

# ARTIFACTUAL THOUGHTS: FUTUREFARMERS IN THE DESERT

PATRICK KILEY

ON A FLAT WHITE BACKGROUND, with light shining in from the left to cast a thin shadow underneath, three distillations:

1) The first nail is forged from a sampled meteorite, a fist of iron minerals that is itself a fragment of a large asteroid that exploded into Arizona fifty thousand years ago. It looks like it could have been unearthed at a Greek archaeological dig, the inky sheen on its dark metal catching one's eye in the dirt. It has a tapered body, stout and squarish at the top, narrowing to a nib. The squat head juts out like the slab serifs in certain typefaces, and there are pits along its shank and a subtle wobble in its downward line. Definitely hand wrought.

2) The second nail is cast from zinc-coated steel pennies minted in 1943. It is a tight cylinder with a sharp point, machinelike. Deep scratches break across its hard surface, like a moon or other astronomical body scarred by obscure events. It is silver with bronze flecks as well as inexplicable touches of shimmery cyan just below the round, cap-like head.

3) The last nail is fused from Trinitite, a grainy, vitreous compound that atomic heat melted together from desert sand. Of all three, it is the least like a nail in appearance, and thus is the most sculptural. It is rough and granulated and mildly radioactive, with the gradual narrowing of a medieval longsword.

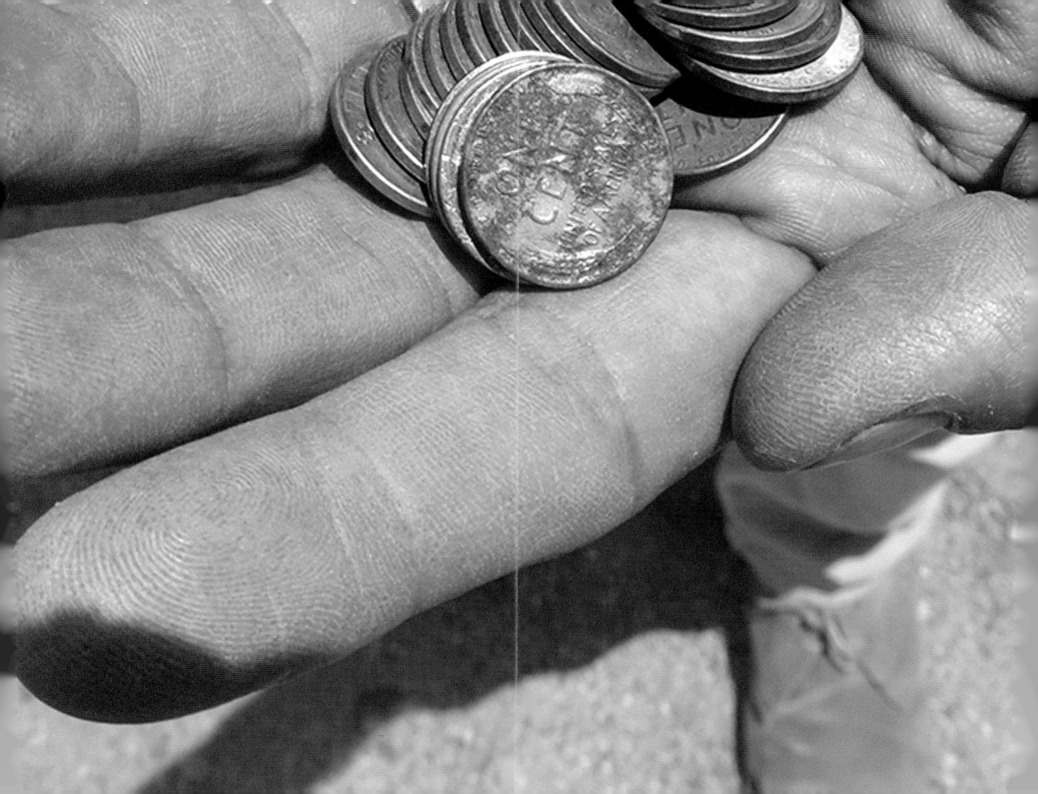

*For Want of a Nail* is a constellation of art projects reflecting on the invention and testing of the atomic bomb at Los Alamos National Laboratory. The New Mexico desert is the locus for these investigations, and the historic events that took place in and around the Project Trinity test site in the early 1940s provide the context. But the essential experience the artists explore and create goes beyond the desert into a distinctive inner landscape familiar to any reader.

The experience of *thinking* and its closely related collateral process, *remembering*, are essential to this project. Futurefarmers produce materialized thinking, lending their series of concrete experiments the feel of a Socratic dialogue or meditation, something that "tends toward a vision." Unlike ordinary thinking, which may be expressed in judgments related principally by language, Futurefarmers manifest these thinking experiences in acts of artistic *poiesis* (fabrication, or "bringing-forth"). They create forms and objects that carry and give appearance to their thinking and remembering—including this book. Their admirers will recognize this peripatetic style, this creative process of thinking and making that circumambulates a place, everywhere in their body of work.

When Amy Franceschini and Michael Swaine found two memos from the office of J. Robert Oppenheimer containing repeated requests for a table for his telephone and a nail for his hat, the repetition caught their attention and caused them to hesitate, to interrupt themselves, "as a way to meditate on the implications of *that larger decision*," they have explained. They went on to create three nails by three different methods, and recorded actors trying to re-collect the designated table from its constituent parts, strewn about on the floor.

Right here, at the beginning of the story, we find the artists working by way of intuition and embracing the potential of metaphor to make or disclose an elusive meaning. "Analogies, metaphors, and emblems," writes Hannah Arendt in her book *The Life of the Mind* (1978), "are the threads by which the mind holds onto the world even when, absentmindedly, it has lost direct contact with it." What we have here is a claim made by the artists that should strike us as unusual but not entirely foreign. It's a fundamentally poetic claim, that something of great historical importance can be gotten at and made meaningful through a tiny pinhole of ordinariness. The artists begin as close to the invisible as archival research allows, meditating on the dawn of the nuclear age by way of something so commonplace as a memo, a table, or a nail. Metaphor, once activated, generates thoughts and meanings profusely—so, for instance, we can observe that atomic fission, the explosive phenomenon underlying this whole inquiry, likewise begins at the level of the invisible.

Again, Arendt is emphatic in making a strange connection: "I could with some justification say that not only distances but also time and space themselves are abolished in the thinking process."

To grasp what Arendt means by this, we need to note the process of withdrawal from the physical world or "de-sensing" that, she writes, the mind must do to transform a sense-object (like a nail) into a "thought-thing" for thinking with—or, in the case of memory, an image that can be stored away and recalled. The power to do this she calls "imagination." Crucially, the image the mind summons does not appear inwardly in the same way as the original physical thing whose absence it makes present, "as though remembrance were a kind of witchcraft," Arendt writes. Whether this interior image or phantasm is understood to be purely "mental" in nature, or something physically stamped into the mind like a signet ring into a wax tablet, as the ancients held,

the central point is the same: Thought takes possession of the "thought-thing" and memory claims the image by way of a necessary loss incurred during a weird alchemy.

For this reason, memory, which survives through images, has always been associated with loss and the power of reclaiming what is otherwise invisible. The best example is an origin story from antiquity that echoes uncannily with Futurefarmers's work at Los Alamos. The classical "art of memory," as traced by Frances A. Yates in her seminal book on the subject, was itself born in the wake of catastrophic loss. Sometime in the fifth century B.C., the Greek poet Simonides, after singing a lyric in honor of his host at a banquet, is mysteriously called outside—just before the roof of the hall collapses, killing everyone inside. The victims' bodies are so badly mangled that their relatives cannot identify them. But, as Yates explains, "Simonides remembered the places at which they had been sitting at the table and was therefore able to indicate to the relatives which were their dead."

The "architectural mnemonic" that Simonides is credited with discovering from this episode of loss rests on the key observation that "orderly arrangement is essential for good memory." The practitioner of this mnemonic used it for the rhetorical purpose of forming and delivering arguments in writing or live debate. He learned to visualize a series of adjacent, well-lit backgrounds (*loci*), with the classic example being a set of intercolumnar spaces below arches: a sort of arcade. He would then "place" within the backgrounds evocative and detailed images representing specific concepts or words that needed memorization. To recall the things or words simply required mentally walking through the rooms of memory and "seeing" what was there.

The question of order in memory, especially as a

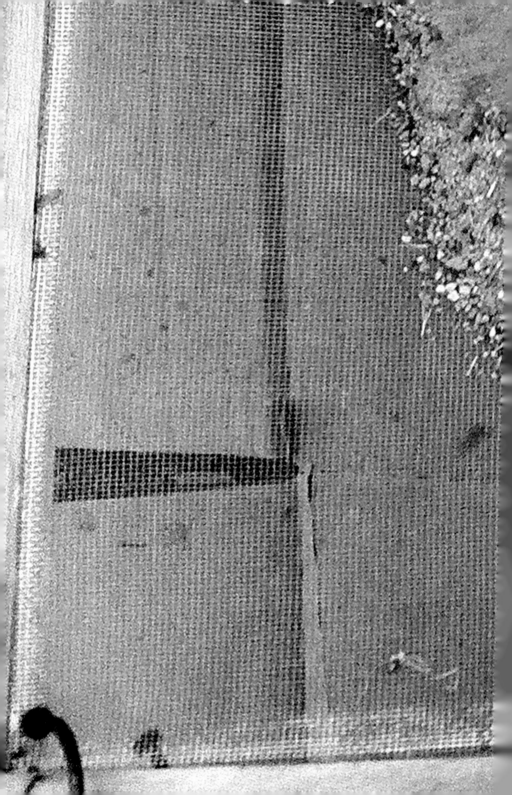

feature of all examples of so-called mnemotechnic developed from antiquity up through the Renaissance (the architectural mnemonic is one of many), sticks out in light of Futurefarmers's evident *resistance* to utilitarian order throughout their project. If this is memory work, how can they escape the demands of tight organization?

An example of this resistance is found in their video-recorded "casting call" for actors to reconstruct Oppenheimer's table—a sort of black-and-white silent film—we see a sequence of people trying to make sense of the various wooden parts without apparent success. Ultimately there is no solution because the actors enter and disappear by way of slow dissolves; at any given movement two or three mildly vexed people may be working on the table problem at once. Though our perspective is fixed, the room itself is in flux. The table appears multiply as several ghostly, partial constructions. In this way, we become witnesses to a kind of soundless conversation that ends not in knowledge but in puzzlement, the signature aporia that Socrates invariably arrived at in his dialogues.

The point here is that Futurefarmers reproduce elements of mnemotechnic—the composition of detailed images and static backgrounds—but, by playfully disrupting any reliable order with which to make use of them, reveal an aim for their remembering that is not rhetorical and in fact is not instrumental at all. It is a thinking aim, which has to do with creating *meaning* rather than finding definitive truth or knowledge. Arendt compares thinking to "flute-playing" and other performing arts that, unlike the solid pieces of knowledge produced by *cognitions*, "have their ends in themselves and leave no tangible outside end product in the world we inhabit."

The subject of meaning is a fraught one in the modern era, so emphatically questionable

as to be a defining feature of our art and society. The Los Alamos site and its history represent a sort of precipice in that accelerating threat to meaning, to any truly livable meaning at all. This is the context in which this project thinks, as if very carefully staring into a piercingly bright light.

In presenting their work at SITE Santa Fe at the end of 2014, Franceschini and Swaine led the audience in a game of "Reverse 20 Questions" used by the theoretical physicist John Wheeler to illustrate a point about quantum particles. A team of two guessers asked a different yes-or-no question to each person in a group of twenty "answerers"—without knowing that each answerer had already privately chosen a separate object. With each answer given, the remaining players had to imagine a new object to fit with the shifting logical boundaries. The result is a game with two fluctuating poles that could go on indefinitely because

the sought-after knowledge at the center is subject to the unpredictable motion of the dialogue. It was Socrates, again, who likened thinking to a swift current or "invisible wind," which we have an intimation of here. A comment by Arendt suggests what this mental motion means for a parlor game that is supposed to demonstrate the fixing power of language and deductive reasoning: "The trouble is that this same wind, whenever it is roused, has the peculiarity of doing away with its own previous manifestations. ... It is in this invisible element's nature to undo, unfreeze, as it were, what language ... has frozen." (We may be reminded of the devastating "blast wind" created by a nuclear explosion, which approaches the speed of sound.)

"Frozen" is a word we could use to describe the utterly still images of the three nails, the "Trinity" that fastens this book together. The images have the fascinating simplicity of letterforms, if one can remember what it was like to look at

words before learning to read. A word and its full suite of definitions beside each nail points to how it was produced while also casting a net of possible meanings. Wordplay is an organizing habit for Futurefarmers because it is so useful in opening passages into the plural nature of thinking and the material world. And because it is the connective tissue of metaphor, the "thought-thing" that thinking unfreezes. Arendt notes that this move to "unfreeze" a word is a kind of thinking that medieval philosophers called "meditation." It stands out as characteristic of the meditating, questioning artist to take a definition as a point of departure rather than a goal or end point.

But the nails, and this book, are, after all, examples of a "tangible outside end product." It would seem to contradict the notion that the process Futurefarmers is engaged in is a purely "thinking" or "remembering" one. Surely this is true by any strict definition, though the sheer ongoingness of *For Want of a Nail* suggests a poetics of these limitless interior experiences. Which is to say that the artists pose questions about thinking and remembering like, *What forms can it take?* and *What is the experience of doing it like?* As artists they are compelled to find some medium for rendering their poetic inquiry—a set of nails, an experiment with a table, a game, a book—but these artifacts and situations tend to narrate or emblematize their questions rather than yielding any "new information."

What conclusions can we draw from this body of poetic research? First, we can say that, if thinking is a silent dialogue one has with oneself, any attempt to bring thinking out into the "world of appearances" will mean that it has to be *participatory* and will not give tangible results as we might expect from social projects. It will go on and on among people building up possible meanings, until the camera runs out of storage or the desert runs out of sand.

they convened there are rendered here in the *gatherings* (folded sections) of these pages. That it is presented to us, the readers, as an "unopened" book is appropriate to this insistence on particularity. This unopened format originates in the desire not only to preserve intact the printed text, but also the physical object's bibliographical details, namely the size of the sheet it was printed on.

# PROVERB

FOR WANT OF A <u>NAIL</u>,

FOR WANT OF A <u>HORSESHOE</u>,

FOR WANT OF A <u>HORSE</u>,

FOR WANT OF A <u>RIDER</u>,

FOR WANT OF A <u>MESSAGE</u>,

FOR WANT OF A <u>BATTLE</u>,

FOR WANT OF A <u>WAR</u>,

Second, we can say that a material thinking will show itself by its devotion to plurality. Three nails rather than one, multiple builders and several tables, layered and not isolated definitions: a profusion of forms and versions. We can say that remembering which is embodied will keep its dependence on images but find ways to make them appear as immanent projections in the surrounding world, "visions" that cannot quite resist objectivity. And just as the images of memory draw potency from feral metaphor, the artist's hand wrought image will be distinguished by a sea change in our expectations of it. Fragments of the environment that seem ordinary and even dead will become, in the hands of the remembering artist, "something rich and strange" (this phrase from Ariel's Song in the *The Tempest*).

The last thing we gather about an artist who performs remembering is that they must refer unmistakably to loss or absence. This is the salience of the proverb Futurefarmers take their title from. "For Want of a Nail" makes a subject of lack and loss—the precondition of remembering—which, line by line, races into the future with fatalistic efficiency: the kingdom is already lost as soon as the nail has been forgotten. Memory's power of reclamation unlocks this chain reaction by offering a way back into contingency, the ground of possibility. An event that is contingent is one that *could have gone another way*. Memory in the hands of the artist is a tool for making something new from the fragments of loss.

Historian Mary Carruthers's study of "memorial culture" in the Medieval period gives us a version of memory that suggests such possibilities for art making—even if it was actually applied to rhetorical purposes historically. She describes a prerational and emotional mental process for bringing things past back into presence. It was an inherently compositional art, unlike some modern notions of memory that liken the mind to a mimetic instrument or computer shuffling through preexisting bits of data. As this tradition descended from the "architectural mnemonic" of Simonides's oral culture to the writing- and book-focused Medieval world, a whole lexicon formed to describe the ways a reader-writer would create new arguments from many texts using memory. The importance of the distinctive image and of arranging or "placing" these images remained central, though the "site" chosen for this mental arrangement could as easily be a figure derived from a gridded folio page as from an architectural source.

Meditation (*meditatio*), which took place during or after reading, was a "free play of the recollecting mind," which notably required a quiet setting like a library or archive. Here the substance of one's reading was absorbed, almost like food, by a process of *divisio* that recognized its discrete fragments and stored them away in a state of "intense, aroused attention." This process in turn prepared the memory for a creative stage (*compositio*) in which the mind "gathered" (*collatio*) and recombined these fragments—all represented by images—from many texts, organizing them like "planks or bricks" in a new design. This new design, what all this memory work was for, was something called the *res*. In this rhetorical context, the best translation of *res* is "gist"—as in the gist of an argument, the model of one's rhetorical composition.

Outside of rhetoric, the *res* is hugely meaningful also in appreciating a work of art, as it refers to something in its particularity, characterized by "thisness" (*haecceity*). *For Want of a Nail* has generated a series of such unique particulars—including the *res* that is this book—which beguile us by incorporating certain essences that seem lost or beyond recovery. The "gathering" the artists did in New Mexico and the gatherings

… THE HORSESHOE WAS LOST.

… THE HORSE WAS LOST.

… THE RIDER WAS LOST.

… THE MESSAGE WAS LOST.

… THE BATTLE WAS LOST.

… THE WAR WAS LOST.

… THE KINGDOM WAS LOST.

THE LATIN ROOT FOR THE WORD "MEMORANDUM"

STEMS FROM "A (THING) TO BE REMEMBERED."

IMAGE 1
VIDEO STILL FROM *Casting Call*, 2014

I live in the Managerial Age, in a world of "Admin." The greatest evil is not now done in those sordid "dens of crime" that Dickens loved to paint. It is not even done in concentration camps and labor camps. In those we see its final result. But it is conceived and ordered (moved, seconded, carried and minuted) in clean, carpeted, warmed and well-lighted offices, by quiet men with white collars and cut fingernails and smooth-shaven cheeks who do not need to raise their voices.

—C. S. Lewis, Preface to The Screwtape Letters, 1942

IMAGE 2
PRODUCTION STILL FROM *Coin Toss*, 2014

During his first visit to New Mexico's Trinity Site, where the world's first atomic bomb test occurred, polymer scientist Robb Hermes could feel the military police watching him. Or maybe it was just his nagging conscience. Milling around with other tourists, he had to fight the urge to bend down, pretend to tie his shoes and swipe a piece of Trinitite—a glassy, mildly radioactive mineral created by the explosion 68 years ago.

Removing Trinitite from the site is a federal crime. But Hermes was fascinated by the strange material and wanted to figure out how the little bits formed in the heart of an atomic blast. He returned to his office at Los Alamos National Laboratory, called up officials at the U.S. Army's White Sands Missile Range (home to Trinity) and asked for a box of ant sand. Ants, he knew, build their mounds from mineral grains gathered up to 15 meters from their homes.

"I thought if I could get some ant sand, maybe I'd find at least a vial of little Trinitite pieces collected from around the site," says Hermes.

When the sand arrived in the mail, Hermes and a geology club friend did indeed discover beads of Trinitite. The pieces were surprisingly spherical, which turned out to be the key to piecing together how the mineral formed.

Hermes found, the atomic blast tossed sand up and melted it to form Trinitite, flinging droplets up to 1,800 meters from ground zero. Some drops solidified before hitting the ground, and some collected into puddles of molten material. In analyzing Trinitite's makeup, Hermes even found colorful traces of steel and copper from the tower that held the bomb and from the wires connected to the instruments.

He has since gotten the Army's blessing to do his Trinitite research. Hermes, now retired, supplies the ant sand to geologists who study meteorites.

—Devin Powell, "Atomic Ant Sand," Science News (August 2013)

IMAGE 3
*The Reverse Twenty Questions Clock*, 2014

In June 1949, as part of a larger investigation on the possible mishandling of "atomic secrets" during the war, [Frank Oppenheimer, Robert's younger brother who founded the Exploratorium in San Francisco] was called before the United States Congress House Un-American Activities Committee (HUAC). Before the Committee, he testified that he and his wife had been members of the Communist Party for about three and a half years. In 1937 they had been involved in local attempts to desegregate the Pasadena public swimming pool, which was open to non-whites only on Wednesday, after which the pool was drained and the water replaced. … After being branded a Communist, Oppenheimer could no longer find work in physics in the U.S., and he was also denied a passport, preventing him from working abroad. Frank and Jackie eventually sold one of the Van Gogh paintings he had inherited from his father, and with the money bought land in Pagosa Springs, Colorado, and spent nearly a decade as cattle farmers.

— Wikipedia entry on Frank Oppenheimer

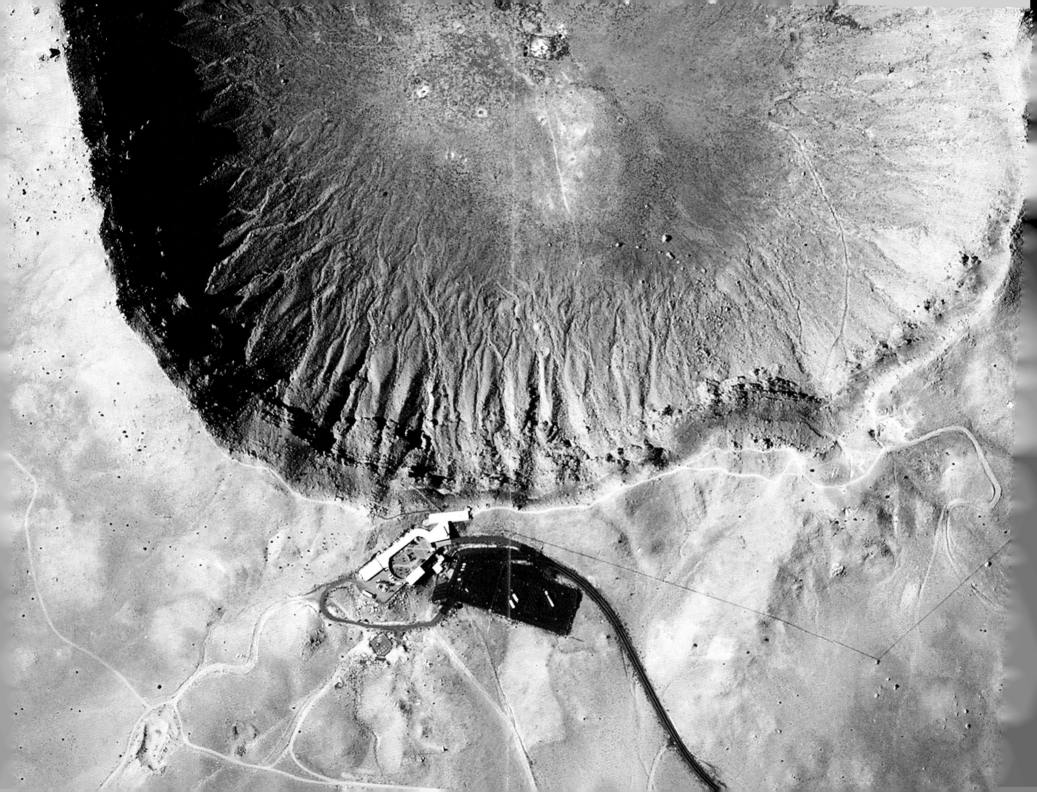

IMAGE 4
*Nails for Robert Oppenheimer: Trinitite*, STEEL PENNIES,
METEORITE

If you hammer a nail into a piece of wood, the wood has a different resistance according to the place you attack it: we say the wood is not isotropic. Neither is the text: the edges, the seam, are unpredictable. Just as (today's) physics must accommodate the nonisotropic character of certain environments, certain universes, so structural analysis (semiology) must recognize the slight resistance in the text, the irregular pattern of its veins.

—Roland Barthes, The Pleasure of the Text, 1973

IMAGE 5
VIDEO STILL FROM *Casting Call*, 2014

The line which separates a witness from an actor is a very thin line indeed.

—James Baldwin, I Am Not Your Negro: A Companion Edition to the Documentary Film, 2017

IMAGE 6
PRODUCTION STILL FROM *Coin Toss*, 2014

Leon D. Smith joined the Manhattan Project in 1944 ... After completing a series of drop tests of weighted "Fat Man" bomb cases, he and two other weaponeers were relocated to Tinian Island in the Pacific. ... When the time came for the August 6 mission, the three men flipped coins to decide who would monitor the first atomic bombs on the Hiroshima and Nagasaki missions. Morris Jeppson flew on the Enola Gay for the Hiroshima mission, Phil Barnes rode in Bockscar for the Nagasaki mission and Smith flew to Iwo Jima as backup for those missions.

—Jay Donahue for the Atomic Heritage Foundation

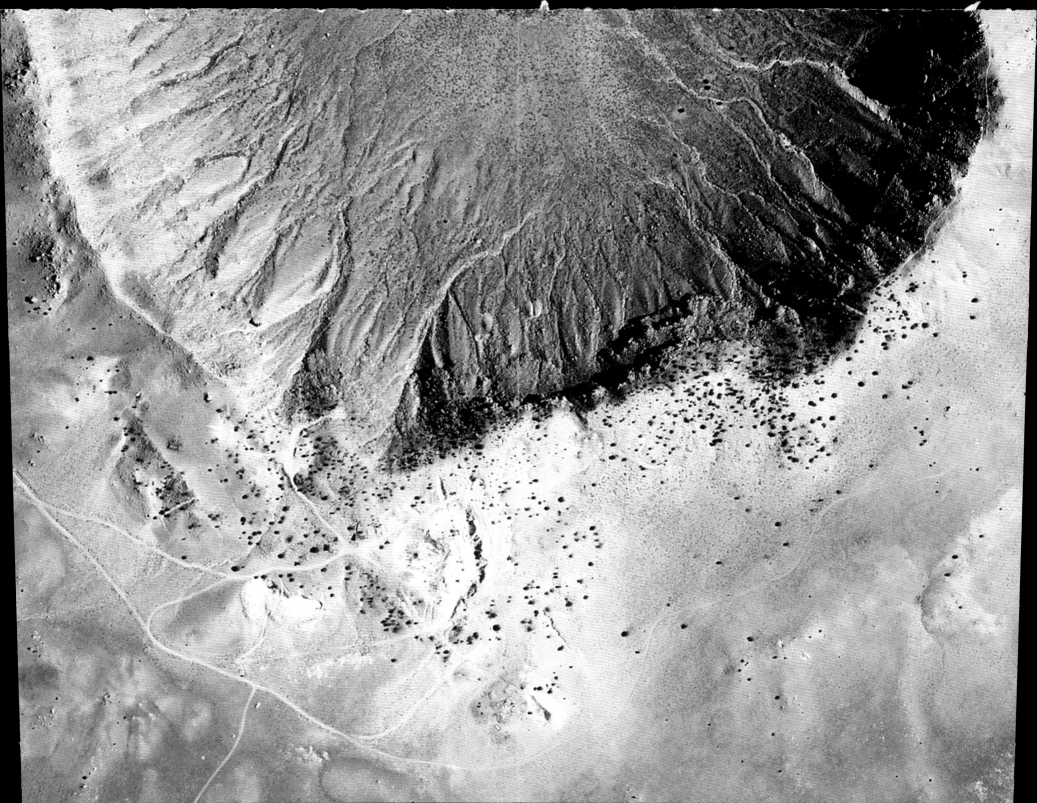

IMAGE 7
SIFTING SOIL IN SEARCH OF TRINITITE, TRINITY, NEW MEXICO, 2014

**Shigeko Sasamori: Hiroshima never had (fire) bombs dropped. But the city people thought they needed wide streets in case bombs dropped. So people could run away. … Young students like us were mobilized. Students cleared the rubble to make nice streets. On August 6 for the first time we went to work.**

**James Yamazaki: You were working outside?**

**Sasamori: Then, I saw a completely different scene from before. People coming out from center. Hurt people … but no noise. Still I just couldn't hear anything. I just followed the people nearby going down to riverside. I went by the river and followed them down to the river's edge. … The people, so many people burnt and naked. No skin, some skin coming off. I can't explain. How horrible it was. Then in my mind—so white. I couldn't think straight. I couldn't think. What happened?**

**—Shigeko Sasamori in conversation with James Yamakazi**

IMAGE 8
BARRINGER CRATER (METEOR CRATER), NEW MEXICO, FORMERLY
KNOWN AS CANYON DIABLO CRATER

One day I discovered that the workmen who lived further out and wanted to come in were too lazy to go around through the gate, and so they had cut themselves a hole in the fence. So I went out the gate, went over to the hole and came in, went out again, and so on, until the sergeant at the gate begins to wonder what's happening. How come this guy is always going out and never coming in? And, of course, his natural reaction was to call the lieutenant and try to put me in jail for doing this. I explained that there was a hole.

You see, I was always trying to straighten people out. And so I made a bet with somebody that I could tell about the hole in the fence in a letter, and mail it out. And sure enough, I did. And the way I did it was I said, You should see the way they administer this place (that's what we were allowed to say). There's a hole in the fence seventy-one feet away from such and such a place, that's this size and that size, that you can walk through.

Now, what can they do? They can't say to me that there is no such hole? I mean, what are they going to do? It's their own hard luck that there's such a hole. They should fix the hole. So I got that one through.

—Richard Feynman, "Surely You're Joking, Mr. Feynman!": Adventures of a Curious Character, 2018

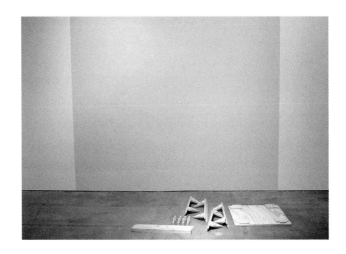

IMAGE 1:
FUTUREFARMERS, VIDEO STILL FROM *Casting Call*, 2014.

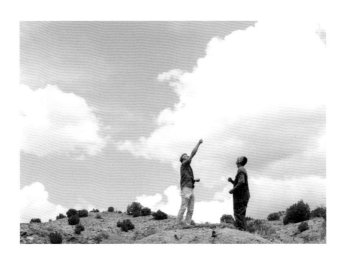

IMAGE 2:
FUTUREFARMERS, PRODUCTION STILL FROM *Coin Toss*, 2014.

IMAGE 3:
FUTUREFARMERS, *The Reverse Twenty Questions Clock*, 2014,
PUBLIC PROGRAM AT SITE SANTA FE, 2014.

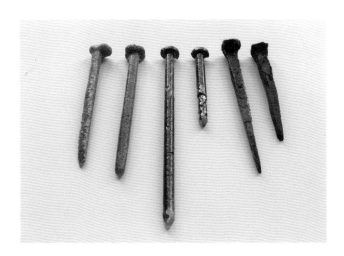

IMAGE 4:
FUTUREFARMERS, PRODUCTION SHOT OF *Nails for Robert
Oppenheimer*: TRINITITE, STEEL PENNIES, METERORITE.

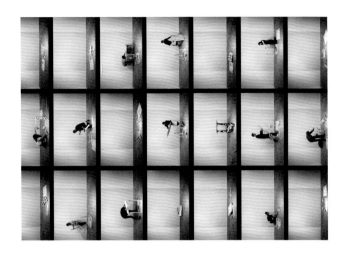

IMAGE 5:
FUTUREFARMERS, VIDEO STILLS FROM *Casting Call*, 2014.

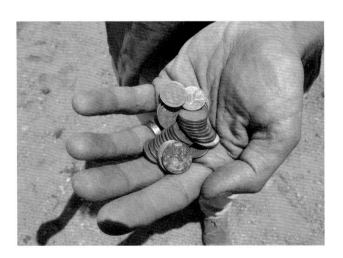

IMAGE 6:
FUTUREFARMERS, PRODUCTION STILL FROM *Coin Toss*, 2014.

**IMAGE 7:**
SIFTING SOIL IN SEARCH OF TRINITITE, TRINITY,
NEW MEXICO, 2014.

**IMAGE 9:**
FUTUREFARMERS, VIDEO STILL FROM *Coin Toss*, 2014.

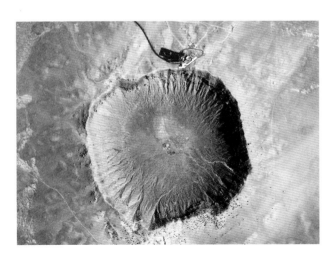

**IMAGE 8:**
BARRINGER CRATER (METEOR CRATER), NEW MEXICO,
FORMERLY KNOWN AS CANYON DIABLO CRATER.

**COVER IMAGE:**
FUTUREFARMERS, VIDEO STILL FROM *Coin Toss*, 2014.

**FORGE:** This book has been fueled by a desire to share a mesh of overlapping histories and geographies related to one event — the test of our most powerful man-made tool, the atomic bomb, on July 16, 1945. *For Want of a Nail* presents an unending generosity of partners who helped us in realizing a curious desire to forge a nail for Dr. J. Robert Oppenheimer.

We would like to acknowledge Irene Hofmann, Phillips Director and Chief Curator, SITE Santa Fe, New Mexico, for her invitation in 2014 to Futurefarmers to participate in SITELINES: The Biennial of the Americas at SITE Santa Fe, where *For Want of a Nail* was conceived. Irene made a leap of faith toward our work in 2003 by including us in the California Biennial at the Orange County Museum of Art and again during her directorship of the Contemporary in Baltimore. She has opened her home to us, lent us her cars, and nurtured a durational relationship to our work.

An extended thank you to: Lucy Lippard for introducing us to Eric Blinman, State Archaeologist of New Mexico. His consultation sourcing iron led us to use meteorite as material as opposed to iron harvested from abandoned iron mines on BLM land.

Michael Sturtz and Chris Niemer of The Crucible, Oakland, California, for forging the meteorite into a nail; Tom Joyce, blacksmith, New Mexico, for counseling us on the forging process.

As this project moves beyond its presentation in a museum to a book that you hold in your hand, we would like to acknowledge our ever faithful and genius designer, Geoff Kaplan. Thank you for keeping us together with humor and grace throughout. We are also grateful to our contributing writers Megan Prelinger and Rick Prelinger, Anne Walsh, Lucy Lippard, Peter Galison, and Patrick Kiley.

A warm thank you and introduction to our new publisher, no place press — Rachel Churner, Jordan Kantor, Geoff Kaplan — for caring for this work and including us in your first crop of published works.

**CAST:** This book has been made possible by an extensive constellation of supporters in addition to those listed above. We are especially grateful to our institutional sponsors: the Firestone Graham Foundation and the University of Washington Junior Faculty Development Award and the Wyckoff Milliman Endowment for Faculty Excellence. Production support: Dan Allende, grip, location scout; Erikka Renedo Illarregi, intern; Jin Zhu, photography; Patrick Kiley for publishing an earlier edition of *For Want of a Nail* through Publication Studios; Basket Bob for hosting, problem solving, and harvesting energy from the sun; David Cole for casting several nails from coins and always taking leaps with us; Joey Chavez (actor whose grandmother quit working at the Manhattan Project when she figured out what they were making); Max Protetch's 142 143 FOR WANT OF A NAIL Hoopdie; Stijn Schiffeleers, video editing; Nina Elder, keeper of the table; Kobe Matthys, counsel, phantom collaborator; Museum of Capitalism; Jim Voorhies, Daisy Nam, and Dina Deitsch of the Carpenter Center for the Visual Arts, Harvard University.

**REFUSE:** One in every six U.S. prisoners during World War II were conscientious objectors who refused to serve in the military.

"To the rights enshrined in the Universal Declaration of Human Rights one more might, with relevance, be added. It is 'The Right to Refuse to Kill.'"
—Assistant Secretary-General of the United Nations, Seán MacBride in his 1974 Nobel Lecture.

And, finally, thank you to Nathan Lynch for refusing to say no to my requests . . . and for letting us melt radioactive material in his ceramic kilns.

Amy Franceschini and Michael Swaine, Futurefarmers
*For Want of a Nail*
Published by no place press

© 2019 Amy Franceschini and Michael Swaine, no place press

Edited by Rachel Churner
Contributions by Peter Galison, Patrick Kiley, Lucy Lippard,
Megan Prelinger and Rick Prelinger, and Anne Walsh

ISBN: 978-1-949484-04-5

Photo Credits: Plates 1, 2: Los Alamos Historical Society, Los Alamos, New Mexico; plates 3, 4, 10: Amy Franceschini; plate 6: Eric Swanson; plate 7: Futurefarmers; plates 8, 9: Michael Swaine; plate 12: Los Angeles Times photographic archive, UCLA Library. Images 1, 5: Futurefarmers; images 2, 3, 6, 8, 9: Amy Franceschini; images 4, 7: Michael Swaine.

Sources: Pages 44–45: Paul Davies, "The Strange World of the Quantum," in *The Ghost in the Atom*, ed. P. C. W. Davies and J. R. Brown (Cambridge: Cambridge University Press, 1986): 23–24; page 116: C. S. Lewis, Preface to *The Screwtape Letters* (London: Geoffrey Bles, 1942): 4; page 117: Devin Powell, "Atomic Ant Sand," *Science News* 184, no. 3 (August 2013): 32; page 120: "Frank Oppenheimer," *Wikipedia*, https://en.wikipedia.org/wiki/Frank_Oppenheimer; page 121: Roland Barthes, *The Pleasure of the Text*, trans. Richard Miller (New York: Hill and Wang, 1973): 36; page 124: James Baldwin, *I Am Not Your Negro: A Companion Edition to the Documentary Film*, 2017; and Jay Donahue for the Atomic Heritage Foundation, https://www.atomicheritage.org/profile/leon-d-smith; page 125: Shigeko Sasamori in conversation with James Yamakazi, "Memoirs of an Atomic Bomb Survivor," http://www.international.ucla.edu/asia/article/20488; page 128: Richard Feynman, "*Surely You're Joking, Mr. Feynman!*": Adventures of a Curious Character (New York: Norton, 2018); page 129: Philip Morrison, "The Atomic Bomb," in *A People's History of World War II*, ed. Marc Favreau (New York: The New Press, 2011): 213.

English
First edition of 1,000
Printed in China

Designed by General Working Group

Distributed by the MIT Press
Cambridge, Massachusetts, and London, England

no place press
New York and San Francisco
noplacepress.com

**▌ no place press**

no place press catalogue:
*Jordan Kantor: Selected Exhibitions 2006–2016*
Edited by Rachel Churner
Conversation with Yve-Alain Bois

Bill Berkson, *A Frank O'Hara Notebook*
Contributions by Ron Padgett and Constance M. Lewallen

Pamela M. Lee, *The Glen Park Library:
A Fairytale of Disruption*
Foreword by Michelle Kuo

Anne Walsh, *Hello Leonora, Soy Anne Walsh*
Contributions by Dodie Bellamy, Julia Bryan-Wilson, and Claudia LaRocco

Amy Franceschini and Michael Swaine, Futurefarmers, *For Want of a Nail*
Contributions by Peter Galison, Patrick Kiley, Lucy Lippard, Megan Prelinger and Rick Prelinger, and Anne Walsh